100 LOST
ARCHITECTURAL
TREASURES
of Old Charlotte

DAVID W. ERDMAN

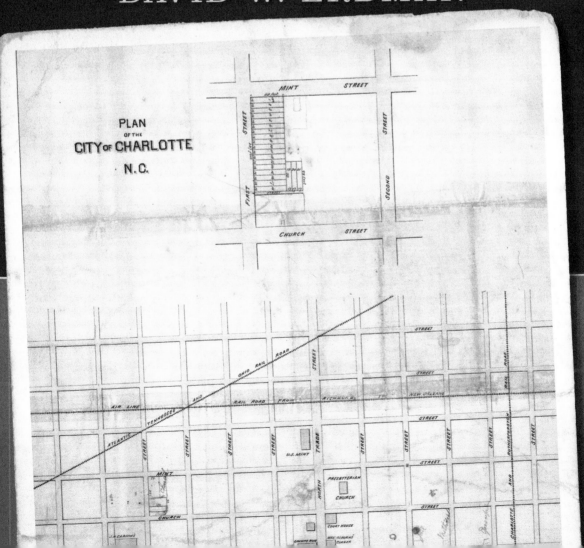

PLAN
OF THE
CITY OF CHARLOTTE
N.C.

100 Lost Architectural Treasures of Old Charlotte
David W. Erdman

Published by David W. Erdman
2300 East Seventh Street, Charlotte, NC 28204

Design and production by SPARK Publications, SPARKpublications.com

Edition One, October 2017, ISBN: 978-0-692-95929-9

Library of Congress Control Number: 2017915004

ARCHITECTURE / Historic Preservation / General
HISTORY / United States / State & Local / South (AL, AR, FL, GA,
KY, LA, MS, NC, SC, TN, VA, WV)
PHOTOGRAPHY / Subjects & Themes / Architectural & Industrial

Dedication

This book is dedicated to the three most important
Charlotte natives in my life – Lynn, Natalie, and Emily.

Cam,

Best wishes for the New Year!

David Erdman

Author

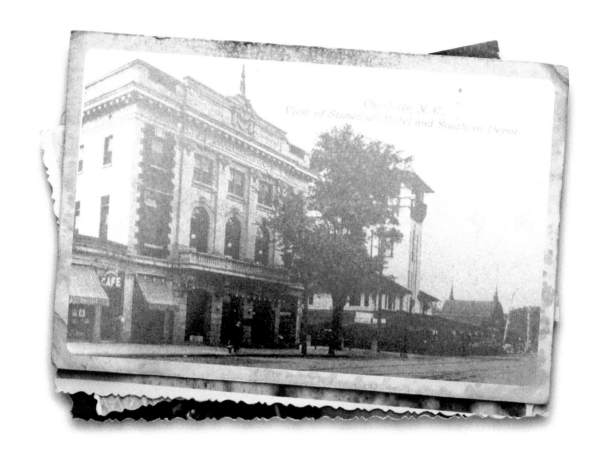

"A true photograph need not be explained,
nor can it be contained in words."

– ANSEL ADAMS

"The palest ink is better than the sharpest memory."

– CHINESE PROVERB

Preface

LIKE EVERY LARGE CITY, Charlotte is the product of the people, events, geography, and circumstances that attracted newcomers over the years and kept them as settlers.

I was such a newcomer and a settler. Unlike my wife and our daughters, I was not born in Charlotte. I did, however, move to Charlotte – the city on which I had pinned my dreams and aspirations – as soon as I could. A native North Carolinian, I was born in Onslow County and was raised in Craven County near historic New Bern.

My New Bern upbringing colors my feelings about Charlotte. New Bern and Charlotte are old cities, both among the handful of North Carolina places that predate the American Revolution. Their histories also intertwine. Charlotte is named for the wife of King George III, the same king who authorized the construction of Tryon Palace in New Bern, making that town the colony's first capital. In turn, Charlotte named its most important street "Tryon Street" to honor (or flatter) the royal governor who resided in New Bern.

With respect to historic preservation, however, these two old cities are opposites. New Bern is home to numerous buildings that date back more than two centuries. History tourism flourishes there. By contrast, most of Charlotte's historic center-city buildings have been trampled in the path of this city's marvelous economic success.

When I arrived in Charlotte in 1976, I searched for the city's historic sections such as those easily located in peer cities like Nashville, Atlanta, Miami, and Columbus, among others. In Charlotte historic areas were not easy to find. Some neighborhoods – most notably old Second Ward – had been obliterated. Today's resurgent neighborhoods now known as South End, West Morehead Street (FreeMoreWest), Wilmore, and North Davidson (NoDa) still held traces in 1976 of Charlotte's emergence as a textile-manufacturing dynamo a century ago. In the 1970s, however, it was difficult to discover even those important parts of the city's history because these now-popular neighborhoods were the forgotten, run-down fringes of the urban core. Fortunately, in the last two decades, these areas have joined Dilworth, Fourth Ward, and Elizabeth in being rediscovered and renewed.

Through photographs, this book brings back 100 buildings that came and went as Charlotte's population burgeoned from being the nation's 60th largest city in 1970 to being the 17th largest city now. Viewing this cavalcade of lost architectural treasures provides context for the industrial and sociological forces that powered this remarkable, still-growing city to its present heights.

Seeing Charlotte's past through pictures of Old Charlotte's lost buildings helps explain the Charlotte Paradox – how did Charlotte become a highly successful city while lacking an obvious geographic reason for its success? Whether the reason was gold mining, textile manufacturing, interstate banking, or connecting the world as an airline hub, the common thread is Charlotte's serial reinvention of itself in each new era. Seeing the city develop over the decades, as these photographs portray, illuminates that history and helps us to understand it.

I never personally saw many of the buildings in this book that fell in the 1950s, 1960s, and early 1970s. Others have been gone so long that no person now living ever saw them. Indeed, most Charlotteans have never seen, except in historic pictures, many of the buildings that appear in this book.

No book can bring back the lost texture of the city's past. These images speak for themselves, communicating messages both of important history and often of grand beauty. They leave no doubt that the Charlotte of today represents a wholesale replacement of Old Charlotte. Perhaps understanding this and remembering all that has been lost will help motivate the citizens of this great city to find ways to preserve the few remaining traces of Charlotte's historic built environment.

Many fine books have been written about Charlotte's history. This book intentionally differs from them in three important respects.

First, this book presents only buildings that no longer exist. Other books that celebrate Charlotte's architectural heritage include still-standing buildings. This book presents only the missing treasures in order to recall the Old Charlotte that no longer exists and to provide the reader a convenient resource to reference and remember these 100 lost buildings.

Second, all buildings are portrayed in actual photographs. One can find many beautiful, color postcards dating back more than 100 years that show some of these same lost buildings. Since color photography was not available when most of those postcards were published, the images on the postcards were creatively colorized from black and

white photographs, with this colorization often taking place as far away as Germany. The colors of the structures as portrayed on the old-time color postcards are hues chosen by artists who never personally saw the buildings. As a result, color postcards exist that portray a single Charlotte building in a dozen different, imagined color schemes. In the interests of authenticity and accuracy, this book presents only actual photographs, usually in their original black-and-white format. This approach best shows the details in old pictures that are often of poor quality to begin with.

Third, the captions with each photograph are solely my own observations, opinions, speculations, and if present, unintended errors. The captions with each building represent a compilation of my thoughts, combined with information gleaned from innumerable books, old newspapers and scrapbooks, reliable internet sources, and photograph albums assembled by many Charlotteans both living and nonliving. Over a lifetime, I have visited hundreds of historic sites in scores of cities. During each visit, I have searched for and have often discovered little-known facts about Charlotte in distant museums. Having resided before moving to Charlotte in a wide variety of other North Carolina towns (Jacksonville, McCain, New Bern, Bridgeton, Cullowhee, Winston Salem, Durham, Greenville, and Raleigh), I have viewed Charlotte's importance to North Carolina from both near and far. My engineering education at Duke University, my law training at Georgetown University, and my lifelong study of United States and North Carolina history all contribute to my observations about the buildings remembered in this book. I welcome your contributions of information about these and other lost buildings, so together we can assemble the most complete history of those lost treasures while working to save the remaining historic structures.

The 250-year history of Charlotte is comprised of a remarkable sequence and confluence of events and circumstances that turned the tiny crossroads that George Washington called "a trifling place" into one of America's largest and finest cities. I hope that this book of 100 lost treasures will help readers connect the city's present with its Old Charlotte past.

David W. Erdman
Charlotte, North Carolina
July 4, 2017

Table of Contents

Preface .. 5

Panoramic Scenes of Old
Charlotte 1900-1916.......................... 10

Charlotte Scenes: A Brief History
of Charlotte 14

First Mecklenburg County
Courthouse 1766 (Replica)..................... 15

General Cornwallis's Headquarters......... 16

Third Mecklenberg County Courthouse... 17

Mint building in its original location...... 18

Central Hotel..................................... 19

North Carolina Military Institute
(D.H. Hill School)................................ 20

Brevard Street Residence..................... 21

Buford Hotel 22

Second Presbyterian Church 23

Ebenezer Baptist Church 24

St. Mark's Lutheran Church.................. 25

"Jacob's Ladder" School....................... 26

1888 City Hall................................... 27

Cotton platform 28

"Ice Cream Parlor House" 29

Family Dollar Store on
West Trade Street............................... 30

1891 City Hall 31

Federal Courthouse and Post Office........ 32

Good Samaritan Hospital..................... 33

Southern Manufacturers Club................ 34

Lawing Building 35

Belmont Hotel................................... 36

Presbyterian College for Women 37

Latta Park 38

Park Elevator Company......................... 39

Fourth Mecklenburg County
Courthouse 1896 40

Elizabeth College 41

Trinity Methodist Church 42

J.T. Williams Home.............................. 43

Clinton Chapel AME Zion Church.......... 44

North Graded School............................ 45

D. A. Tompkins Tower.......................... 46

Circus Day and the
Carson Building 47

Catawba Power/
Southern Power Building 48

Stonewall Hotel.................................. 49

Carnegie Library 50

Charlotte Sanatorium........................... 51

Presbyterian Hospital 52

Piedmont Fire Insurance Company......... 53

Latta Mansion................................... 54

Selwyn Hotel..................................... 55

Hawley Mansion................................. 56

Florence Crittenton Services/
Hotel Alexander.................................. 57

Southern Railway Station...................... 58

Independence Building 60

YMCA .. 61

Law Building (First)............................ 62

Standard Ice & Fuel Company................ 63

American Trust Company....................... 64

Belk Store .. 65

Williams & Shelton 66

Commercial National Bank 67

P&N Freight Warehouse
and Loading Dock 68

Clayton Hotel .. 69

Coca-Cola .. 70

Mecklenburg Hotel 71

Masonic Temple 72

YWCA .. 73

Myers Park Gatehouse 74

Hexagonal House 75

Ryder Flats ... 76

Harry Golden House 77

Camp Greene Army Base 78

Alexander Graham
Junior High School 79

Dowd Flats .. 80

Providence Road Apartments 81

Chamber of Commerce 82

Professional Building 83

Wade Loft .. 84

Merchandising District 85

Eye, Ear & Throat Hospital 86

Second Ward School 87

Hotel Charlotte 88

Race Track .. 89

Walton Hotel ... 90

"Jesus Saves" Building 91

Lamp Lighter Restaurant 92

Wilder Building 93

Law Building (Second) 94

Southern Railway Office 95

Observer-News Building 96

Pound & Moore Company 97

Power Building .. 98

Armory .. 99

S&W Cafeteria (later Southern
National Bank building) 100

Film Row ... 101

Charlotte News 102

Charlotte Municipal
Airport Terminal 103

Virginia Paper Company 104

Doctors Building 105

Pitcher Street Shotgun Houses 106

E.I. Dupont Building 107

Federal Reserve Building 108

Bus Station .. 109

Crockett Baseball Park 110

Kress Store .. 111

Radio Center ... 112

Independence Boulevard
"elbow" intersection 113

Library ... 114

Convention Center 115

Population Chart 116

Acknowledgments 117

Index ... 118

Author's Biography 119

Panoramic Scenes of Old Charlotte
1900-1916

Charlotte circa 1900

View looking north from D. A. Tompkins Tower (No. 32). Buildings visible in this photograph include the Third Mecklenburg County Courthouse 1836 (No. 3) and the 1891 City Hall (No. 17). No building seen in this photograph is still standing.

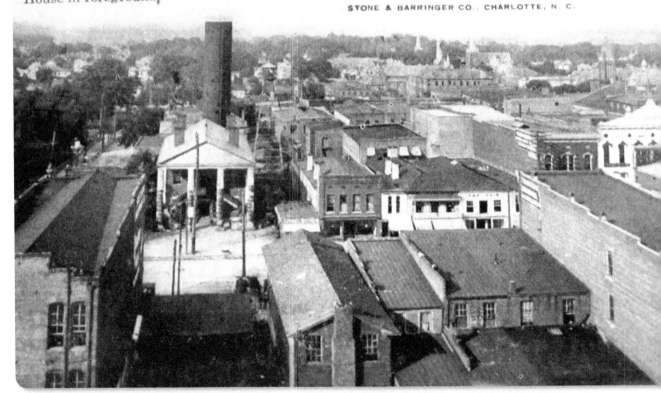

Charlotte. N. C.—Partial view of Northern section of city from Tompkin's tower. City Hall at House in foreground,

STONE & BARRINGER CO., CHARLOTTE, N. C.

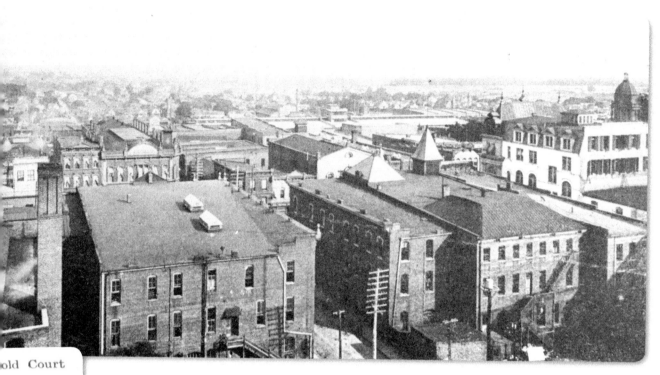

old Court

Charlotte circa 1900

View looking southeast from D. A. Tompkins Tower (No. 32). Buildings visible in this photograph include the Buford Hotel (No. 8), Catawba Power/Southern Power Building (No. 34), and the dome of the 1896 Mecklenburg County Courthouse (No. 26). No building seen in this photograph is still standing.

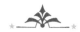

Panoramic Scenes of Old Charlotte
1900-1916

Charlotte circa 1910

View looking north on Tryon Street probably from the Commercial National Bank (No. 52). Buildings visible in this photograph include the Independence Building (No. 45), the 1891 City Hall (No. 17), and the Central Hotel (No. 5). No building seen in this photograph is still standing.

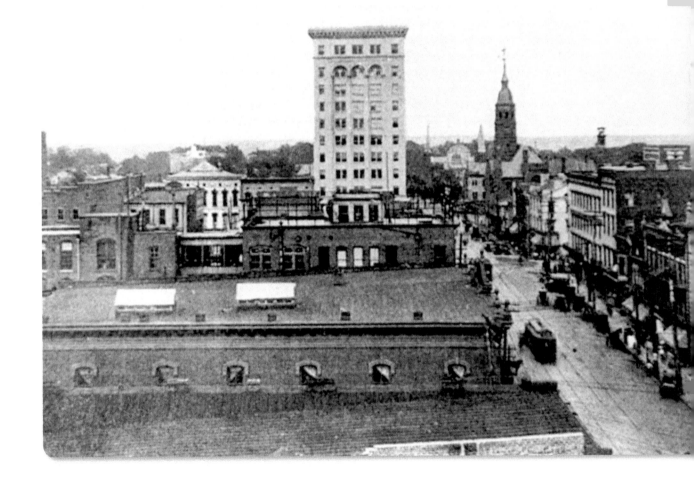

Charlotte 1916

View looking south from the Sanatorium in Fourth Ward (No. 37). Buildings visible in this photograph include Second Presbyterian Church (No. 9), the 1891 City Hall (No. 17), the Independence Building (No. 45), the Commercial National Bank (No. 52), the Selwyn Hotel (No. 41), and behind it the D. A. Tompkins Tower (No. 32). No building seen in this photograph is still standing.

Charlotte Scenes:
A Brief History of Charlotte

Listen up, Charlotte, city named for a queen,

To the folks who came before us, speaking from each scene.

Catawba River forests are rich with deer and bears.

Riverside gardens feed the tribe. The natives trade their wares.

We've named the new town "Charlotte," then we fought King George's best.

When Cornwallis tried to beat us down, he unleashed a "Hornet's Nest."

George Washington visited our town once. "A trifling place," he sneered.

New Bern, the capital, had lots more people, but then Charlotte's gold appeared!

The town of Charlotte mines the ore. Gold coins come from the Mint.

We have iron works and train tracks that of future growth give hint.

We mostly avoided the Civil War. Our tracks are still in place.

While Columbia and Atlanta burned, Charlotte picked up the pace.

The freed slaves have moved to Second Ward. The New South lies ahead.

Hundreds of mills are popping up. They're spinning cotton thread.

The city of Charlotte's growing still. Duke Electric supplies the power.

You can see for many miles from the Independence Building tower.

The bustling city of Charlotte boasts Camp Greene army base,

Training doughboys to fight The War to make this world a safer place.

Women staffed the shell plant – 10,000 strong or more

To make the anti-aircraft shells that won the Second World War.

Lake Norman formed by Cowan's Dam makes our water source secure.

The Overstreet Mall connects Uptown – more businesses to lure.

Interstate banking's a powerful force that spreads the city's name

With Panthers, Hornets, Charlotte Knights, and the NASCAR Hall of Fame.

The urban region Charlotte leads a thousand years will last,

But the future scenes are up to us to build well on our past.

First Mecklenburg County Courthouse 1766 (Replica)

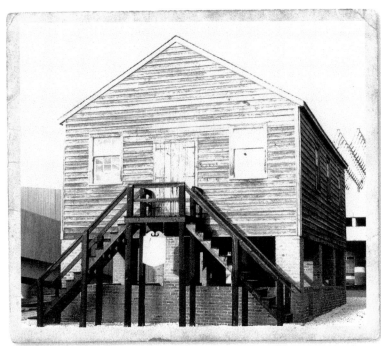

Photograph by Mary Boyer

IN THE ANCIENT WORLD, it was said that "all roads lead to Rome." In Charlotte's history, it can be equally said that, in many ways, all roads lead back to the original Mecklenburg County Courthouse. This photograph shows a replica of that Courthouse, which was built to commemorate America's 1976 Bicentennial. Mecklenburg County was formed in 1762. At that time, Charlotte did not exist. In the 1760s, a handful of settlers had built cabins along the low ridge where Tryon Street now runs. Enterprising from the beginning, those settlers conceived a business opportunity to grow their hamlet. Using their own resources and barn-raising skills, they built the first Mecklenburg County Courthouse in 1766. It stood squarely in the middle of the intersection of the horse and wagon trails that later became Trade Street and Tryon Street. That intersection became known as the Square, a name that continues to this day. The city's foresighted founders anticipated correctly that their crossroads would become the county seat if they were the first in the county to build a courthouse. They foresaw that the courthouse would attract commerce, legal activity, and additional settlers to the area. In 1768, they named their tiny settlement Charlotte. The first Mecklenburg County Courthouse possessed two distinctive architectural features that provided a template for the design of many future buildings in Charlotte. First, the 1766 wooden courthouse was built high above the ground, its first level perched atop 10-foot-tall brick pillars. Second, the structure featured two opposing stairways that ascended to the courthouse's first level. Both architectural motifs – the opposing stairways and the elevated first level – have been copied and incorporated into numerous Charlotte buildings over the ensuing 250 years.

General Cornwallis's Headquarters

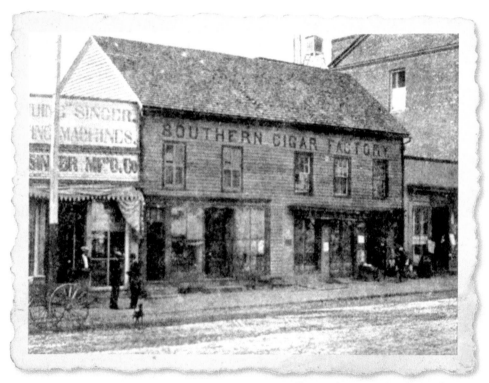

Photograph courtesy of the *Charlotte Observer*

THE BATTLES of the American Revolutionary War that ultimately determined the outcome of the war were fought in the South in 1780 and 1781. The largest British Army commanded by General Charles Cornwallis spent those two years in North Carolina and South Carolina fighting many battles in the Charlotte region. Chasing the army of American General Nathanael Greene, Cornwallis did not have the time nor the manpower to occupy territory even as he won many of the battles. One city that he temporarily conquered was Charlotte. Since the hamlet was named for the wife of King George III, Cornwallis might have expected a friendly reception from the local citizens. Those outnumbered citizens, however, fought courageously against Cornwallis even while retreating in the Battle of Charlotte on September 26, 1780. Cornwallis occupied Charlotte for a couple of weeks during which time he commandeered as his headquarters this building, which was photographed a century later when it was a cigar factory.

Third Mecklenburg County Courthouse 1836

THIS BUILDING, which stood on West Trade Street, is the third Mecklenburg County Courthouse, a state courthouse. Constructed in 1836, it featured twin opposing stairways following the the pattern of the double-opposing stairways on the original Mecklenburg County Courthouse (No. 1). This third courthouse was replaced by the fourth Mecklenburg County Courthouse (No. 26) in 1897. The cylindrical smokestack-appearing structure behind the courthouse is a standpipe, an old-time water tank. The third courthouse was torn down, as shown here, a few years later. First Presbyterian Church, the oldest building still standing in Uptown Charlotte is in the background.

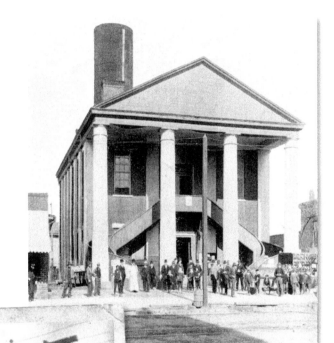

(Left) photograph from Wade Harris's 1909 edition of Sketches of Charlotte

(Right) photograph from Chunk Simmons family album courtesy of Noni Simmons

Mint building in its original location

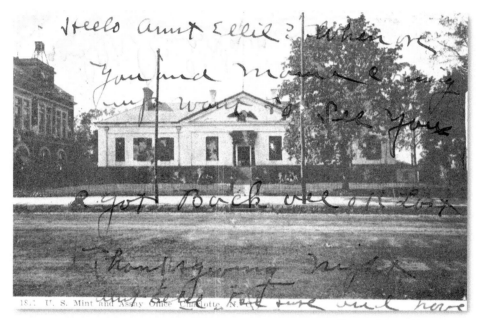

Photograph from 1907 postcard

CHARLOTTE'S UNITED STATES MINT is the only building featured in this book that is still standing. It is not, however, standing where it was originally built on West Trade Street near the intersection of Mint Street. Its surviving manifestation is a stone-by stone reassembled version of the original 1837 Mint. Before the California gold rush, Charlotte was the center of one of America's most productive gold-mining regions. As a result, President Andrew Jackson, a native of neighboring Union County, North Carolina, placed this branch of Philadelphia's United States Mint in Charlotte. Although this mint never produced U.S. coins after the beginning of the Civil War, it stood for almost a century on West Trade Street. In the 1930s, the federal government planned an expansion of Charlotte's combined federal courthouse and post office, which was next door to the Mint. The expansion plan required removal of the Mint building. In a heroic rescue effort led by Charlotte native Mary Myers Dwelle, the Mint building was purchased and disassembled stone-by-stone in 1933. The thousands of pieces were piled up in the then-new Eastover neighborhood. There, the Mint building was reassembled as a project of the federal Works Progress Administration. Restored and refurbished, it opened in 1936. The building now holds a portion of the Mint Museum of Art's significant collection.

Central Hotel

FIRST KNOWN as the Mansion House, this building was erected in 1840 at the Square. In 1873, the hotel's name was changed to the Central Hotel. As its name suggests, the Central Hotel was located at the center of Charlotte, the corner of East Trade Street and South Tryon Street, at today's 101 South Tryon Street address. One of the hotel's early owners was William Treloar whose house still stands at 328 North Brevard Street. In 1880, the original hotel building featured a squared corner at the junction of Trade Street and Tryon Street. By 1883, however, the exterior of the hotel had been renovated so that the building's front corner rooms faced the Square through windows in an angled corner. An 1896 article about the hotel stated that this hotel, along with the Buford Hotel (No. 8), was "specially equipped for the accommodation of Northern tourists." Presumably, travelers in 1896 somehow knew what that description meant in the post-Civil War South. Since then, its meaning has been lost to history. The four-story hotel did not have an elevator. Perhaps Northern tourists did not require elevators! Until Charlotte passed a local prohibition law that closed all taverns in 1905, the hotel featured a first-floor bar that looked out on the Square. In

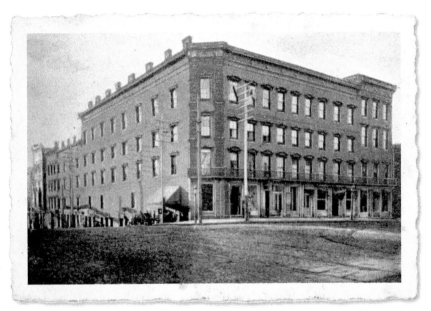

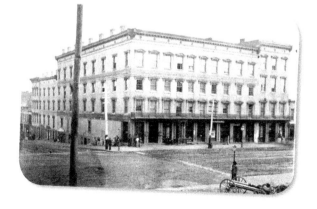

its heyday, the Central Hotel was the largest and finest hotel in Charlotte. The building was razed in 1941, and the Kress Building (No. 96) replaced it.

North Carolina Military Institute
(D.H. Hill School)

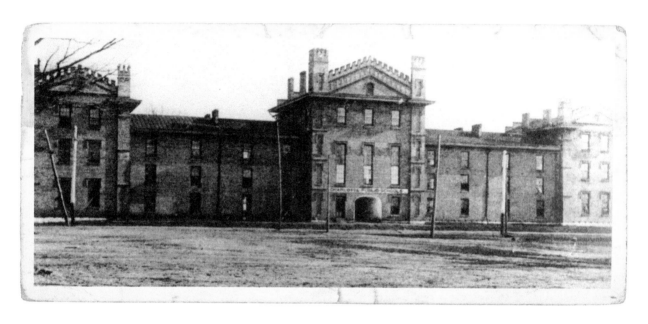

THE SIGN ON THE BUILDING SAYS "Charlotte Public Schools" because, when this photograph was taken, the building was the flagship of Charlotte's incipient public school system. It was known as the South Graded School with 10 grades of schooling. This military-style building was constructed in 1859 as the North Carolina Military Institute, which was similar to the Virginia Military Institute in Lexington, Virginia, and the Citadel in Charleston, South Carolina. The institute was also known as the D. H. Hill School, named after its first superintendent, famous Confederate General Daniel

Harvey Hill. It is said that the school building was used during Reconstruction as a federal prison. At that time before North Carolina was readmitted to the Union, Charlotte was still occupied by the Union Army. Except when the Union Army held the building, the building's history over almost an entire century was its service as an educational facility. This building located on South Boulevard at East Morehead Street was razed in 1954 to make room for a unique multiramp elbow intersection (No. 98) that wove South Boulevard and Morehead Street into Charlotte's first cross-city modern highway, Independence Boulevard.

Brevard Street Residence

LITTLE CONSISTENT INFORMATION is available about this remarkable house built in a High Victorian style at 318 North Brevard Street just before the Civil War. Unlike many places in America in the second half of the 19th century, the Mansard roofline was never widespread in Charlotte. This spectacular exception featured High Victorian style coupled with double-opposing stairways like those found on many of the city's significant buildings since the first Mecklenburg County Courthouse (No. 1) established the theme in 1766. The *Hill's Charlotte* *(Mecklenburg County, N.C.) City Directory* (1935) lists Oscar H. Gaither as the house's resident. Other researchers connect the house variously with the Treloar family, the Rosa and Samuel P. Smith family, and the Baruch family of Charlotte. The latter D. H. Baruch advertised that he operated "the largest Retail Dry Goods Store in the State." His nephew, Bernard M. Baruch, a native of South Carolina who spent time with his uncle in Charlotte, became a world-famous Wall Street financier and advisor to presidents of the United States. This house was razed in 1968.

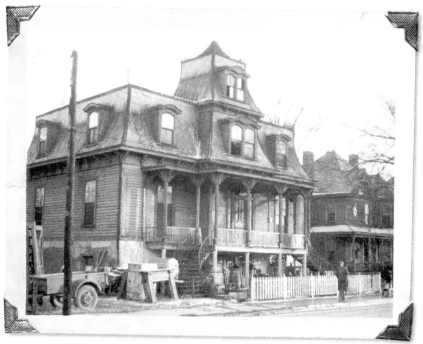

Photograph courtesy of the *Charlotte Observer*

Buford Hotel

THE BUFORD HOTEL, built in 1870 at 139 South Tryon Street with its Mansard-style Victorian tower, played many roles over its life. Throughout most of its history, it was a hotel and a bank. At various times, however, it was also home to the U.S. Post Office, the Charlotte City Club, and the federal court. For almost 20 years, the City Club was located in the front rooms of the second floor of the hotel. The Buford Hotel was the first building in Charlotte to have an elevator. As a hotel, the Buford was a home-away-from-home to innumerable traveling salesmen known as "drummers" when they passed through Charlotte. Paul Harris, the founder of Rotary International, stayed at the Buford Hotel when he regularly traveled to Charlotte as a salesman. Legend has it that his lonely nights in Charlotte inspired him to found the Rotary Club, which would provide him a circle of contacts in whatever city he visited. Thomas Edison, Alexander Graham Bell, and many "cotton mill men" stayed at the hotel. In 1896, the hotel was one of two in the city described as "specially equipped for the accommodation of Northern tourists." In Charlotte's 1899 promotional

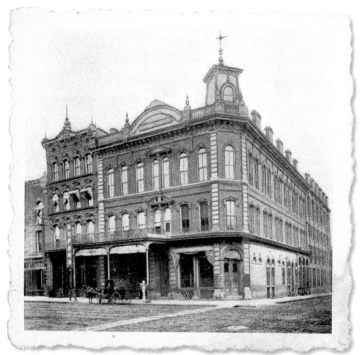

Photograph from from Wade Harris's 1909 edition of Sketches of Charlotte

publication, the hotel is cobranded as the Buford Hotel and Belmont Hotel Annex (No. 22). The numerous chimneys disclose that most, if not all, rooms had fireplaces. In an ill-conceived effort to modernize the hotel building before it was eventually torn down, the decorative but outdated Victorian tower was removed. The building survived until the 1960s.

Second Presbyterian Church

THE SECOND PRESBYTERIAN CHURCH at 210 North Tryon Street was formed in 1873 as an offshoot from First Presbyterian Church, which still stands. (Charlotte also has a Third Presbyterian Church.) This Norman-styled building opened in 1892. Razed in 1947, the Second Presbyterian Church left an enduring legacy for Charlotte as the place of origin of the Good Fellows Club, which began at the church in 1917. A century later, the Good Fellows Club still serves the community as a worthy charitable organization that gives temporary financial relief to Charlotte's working poor in times of crisis. Second Presbyterian Church was also home to Boy Scout Troop 20. The church's congregation migrated to the Dilworth neighborhood and merged with the congregation of Westminster Presbyterian church in 1947 to form Covenant Presbyterian Church, which remains active in Charlotte. Second Presbyterian's Tryon Street building was sold and subsequently razed.

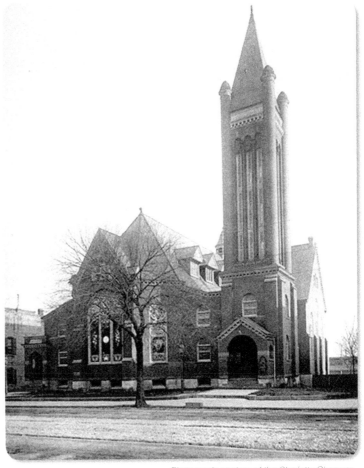

Photograph courtesy of the *Charlotte Observer*

Ebenezer Baptist Church

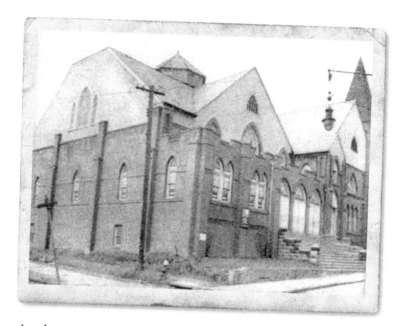

THE EBENEZER BAPTIST CHURCH was built after the Civil War in Charlotte's then-new African-American neighborhood in the city's Second Ward. North Carolina was a slave state until the war ended, at which time all slaves were freed. The immediate result of the war's end was a massive challenge of homelessness for the emancipated African-American families. Since the former slaves were no longer constrained to reside in their masters' slave quarters, they were free to leave or stay. Some chose to stay on the plantations if their former owners offered terms for sharecropping or other financial arrangements that the "freedmen" would accept. Many of the freed slaves who left the plantations in Mecklenburg County migrated to the Second Ward section of Old Charlotte. After the Civil War, in towns throughout the old Confederacy, racial segregation began, with railroad tracks often forming the dividing line between the races. Following that pattern, the black Second Ward neighborhood was on the "other side of the tracks" from white Uptown Charlotte. In Second Ward, the new residents established a separate African-American community sometimes called Brooklyn or Blue Heaven. Out of this newly formed society arose numerous black churches including the Ebenezer Baptist Church at 520 East Second Street, which was organized in 1877. To build such a monumental structure, there was no shortage of skilled tradesmen among the fomer slaves who had built the fine plantation houses and the "white" churches of the Old Confederacy.

St. Mark's Lutheran Church

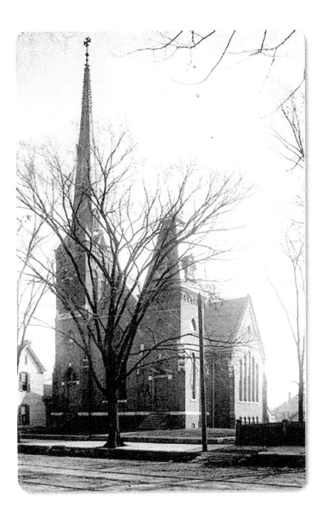

T HE CORNERSTONE from the original St. Mark's Lutheran Church, which stood at 414 North Tryon Street, bears the date October 31, 1885. The church's congregation still lives on under the same St. Mark's name at 1001 Queens Road, a location in Myers Park to which the congregation relocated in 1960. The original church on North Tryon Street was part of the multidenominational enclave of churches on North Tryon Street that included Tryon Street Methodist Church, St. Peter's Episcopal Church, and Second Presbyterian Church. This building, which was next door to the still-standing Barringer Hotel, was razed after the congregation moved in 1960.

"Jacob's Ladder" School

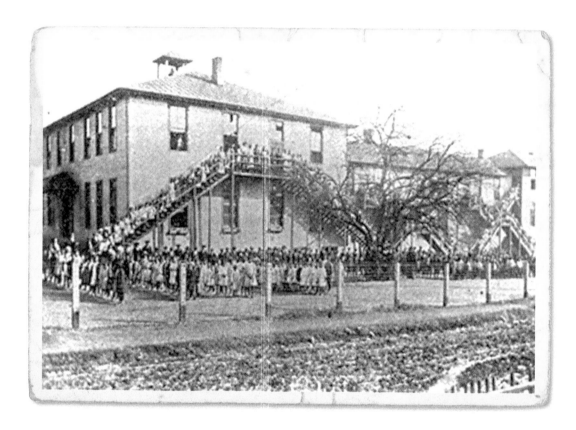

IN 1882, Charlotte founded its first public school for African-American students. This building, the Myers Street School located at 525 South Myers Street, was built in 1886. It served until 1907 as the city's school for African-American students, many of whom, as the descendants of former slaves, may have been the first in their families to be offered a "school" education. It was commonly called the Jacob's Ladder School because of its numerous outdoor stairways. This is an example of the recurring double opposing stairway motif in Charlotte's public buildings originally inspired by the opposing stairways of the 1768 Mecklenburg County Courthouse (No. 1). Today's Harvey B. Gantt Center for African-American Arts + Culture recalls the Jacob's Ladder School by emulating its dual opposing stairs with dual escalators that access the main, second level from either end of the building.

1888 City Hall

UNTIL 1891 when Charlotte opened its formal City Hall, city operations were based in this building on East Trade Street, which primarily served as a fire station. The wide, high arches were tall enough for a horse-mounted rider or a tall horse-drawn steam fire engine to enter or exit. Similar high-rounded, rider-on-horse arches are still found in many 1800s buildings in Charleston, South Carolina, but none are known to survive in Charlotte. In this photograph, the main building is labeled "restaurant and lunch room." This may have been the use to which the building was converted after city operations moved to the City Hall on North Tryon Street (No. 17). Chances are that this restaurant's proximity to the city's busy cotton platform furnished numerous customers seeking to purchase a meal.

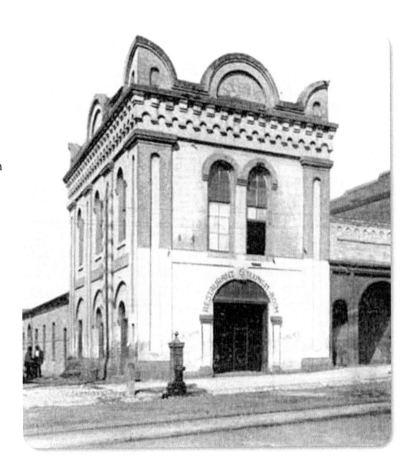

Cotton platform

THIS PHOTOGRAPH from around 1896 highlights a principal motivating force – the ample local cotton supply – that led to the relocation of the center of America's textile manufacturing industry from New England to the Charlotte region of the two Carolinas. The cotton platform was the loading dock from which cotton bales were placed on trains to be carried to textile mills or to ports for export. Like many areas of the South, Charlotte's agricultural operations produced tens of thousands of massive bales of cotton. After the first trains came to Charlotte in the 1850s, cotton was transported from the city by rail to ports such as Charleston, South Carolina, from whence it was carried to the Northeast United States or to England. The first cotton mill in Charlotte began operation in 1881. With the advent of abundant, low-cost electric power furnished by James B. Duke's electric company, coupled with the ample local supply of cotton, Charlotte-based entrepreneurs decided to manufacture textiles in the Charlotte region. Within a couple of decades, it was said that there existed "a mill

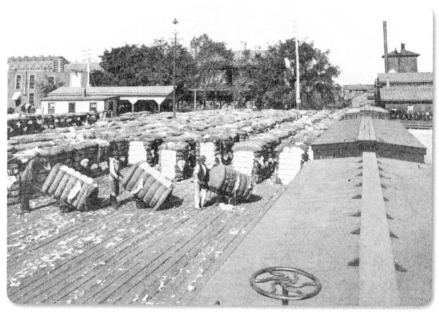

Photograph from Wade Harris's 1896 edition of *Sketches of Charlotte*

a mile" over the hundred-mile rail line extending from Spartanburg, South Carolina, to Kannapolis, North Carolina. That stretch of rails ran through Charlotte. Textile mills operated around-the-clock, six days a week, employing in each mill hundreds or thousands of workers, including young children. The lure of reliable "paycheck jobs" attracted to the city thousands of hardscrabble farming families who were weary of financially unpredictable, seasonal farmwork. As the textile industry boomed, there was as much need to bring cotton into Charlotte to supply the mills as there formerly had been to ship cotton out.

"Ice Cream Parlor House"

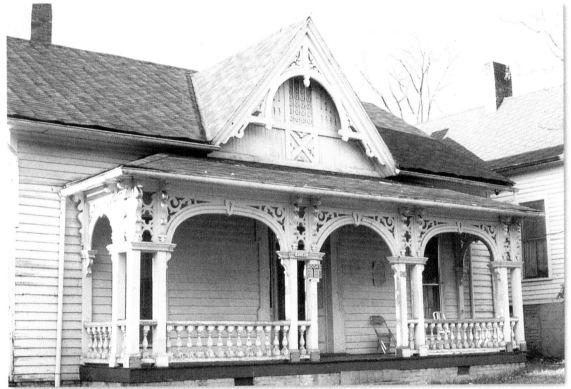

Photograph courtesy of Mary Boyer

THIS HOUSE at 319 North Pine Street in Fourth Ward was dubbed the "Ice Cream Parlor House" by distinguished Charlotte historian Mary Boyer because of its ornate design. After it was bulldozed in the early 1970s, this former residence in Fourth Ward became one of the three most compelling rallying points for historic preservationists in Charlotte. The other two monuments that fell and became martyrs to the preservation cause were the Independence Building (No. 45) and the Masonic Temple (No. 57). The publicized and much-lamented loss of this house spawned a significant and largely successful effort to support historic preservation and the revival of Fourth Ward, which had long been in decline.

David W. Erdman **29**

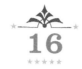
Family Dollar Store on West Trade Street

BUILT BEFORE 1900 for the Yorke Bros. & Rogers Company, this building survived until it burned in a dramatic Uptown conflagration in approximately 1978. The building's distinctive, perhaps initially unintended, design features two horizontal rows comprised of three windows of full width and a narrower window of the same design. The theater next door is one of several movie theaters that were located near the Square before television became widespread. By 1974, when this photograph was taken, the theater, which is also gone, was in its final depressed condition after years of decline.

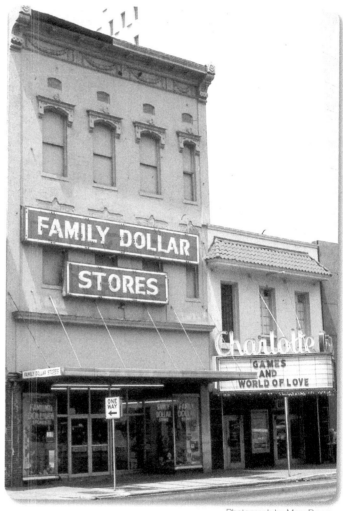

Photograph by Mary Boyer

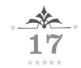
1891 City Hall

WHEN THIS CITY HALL was built in 1891, Charlotte had a population of approximately 11,500 and was smaller than Wilmington and Raleigh. Perhaps sensing, and certainly hoping, that Charlotte was about to soar in population, the city leaders built this monumental City Hall structure befitting a future big city. This 1891 City Hall designed by Scandanavian architect Gottfried Norrman bears some similarity to the famous William Penn City Hall of the City of Philadelphia, although Charlotte's City Hall was built first. Perhaps the building's most popular feature was its large, four-faced clock, which could be viewed from all directions. Atop the building's steeple was a weathervane with the figure of a dragon signaling the wind's direction. Located near the Square on North Tryon Street, this building served the city through World War I, after which it was replaced in the 1920s by a relatively understated City Hall on East Trade Street. The 1920s City Hall still stands, but it was replaced as the seat of city government when the Charlotte-Mecklenburg Government Center opened in the late 1980s. This City Hall was razed in 1926.

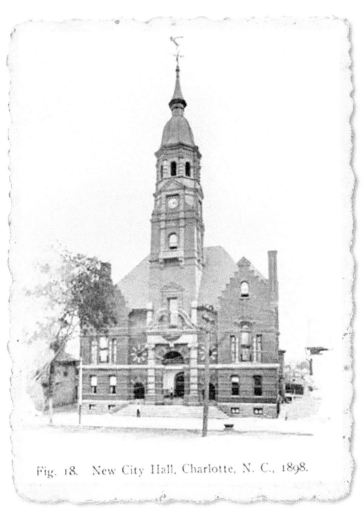

Fig. 18. New City Hall, Charlotte, N. C., 1898.

Photograph from Wade Harris's 1896 edition of *Sketches of Charlotte*

Federal Courthouse and Post Office

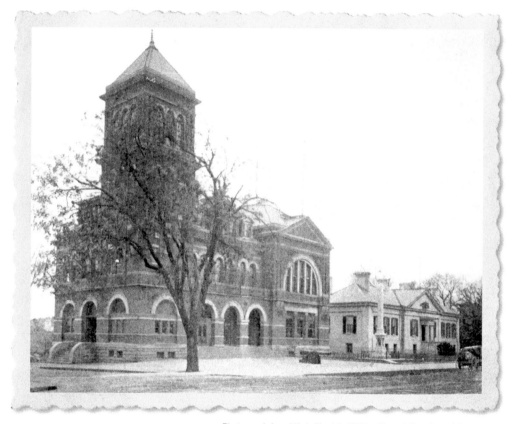

Photograph from Wade Harris's 1909 edition of *Sketches of Charlotte*

THE TWO-BUILDING federal government enclave on West Trade Street illustrated here began with the construction of the U.S. Mint on the site in 1837. The Mint, where gold coins were manufactured from locally mined gold, is the smaller building on the right shown in this photograph. The Mint building (No. 4) was disassembled in 1931 and reassembled on a site in the Eastover neighborhood three miles away. From 1891 until it was razed in 1915, the larger building in this photograph housed the U.S. Post Office on its first floor and the federal courthouse on the second floor. Perpetuating the site's identity as property of the United States government, these buildings were replaced by a larger federal courthouse, which still stands and also served as the city's main post office into the 1980s.

19

Good Samaritan Hospital

Photograph courtesy of Mary Boyer

GOOD SAMARITAN HOSPITAL stood on South Graham Street where Charlotte's NFL stadium is now located. It was a few decades after the Civil War before people generally began to believe that hospitals had a useful purpose other than as a place to die. As the white citizens of Charlotte were beginning to transfer their health-care allegiance to hospitals (and away from home care with doctors making house calls), the black community did not initially have access to hospital care. In 1891, concerned church members of a white congregation, St. Peter's Episcopal Church led by Jane Smedberg Wilkes (1827-1913), created Good Samaritan Hospital for Charlotte's African-American community. Jane Wilkes had already instigated the founding of St. Peter's Hospital,

which still stands on North Poplar Street in Fourth Ward. Good Samaritan Hospital was North Carolina's first private hospital created exclusively for the care of African-Americans. In 1960, the hospital was taken over by Charlotte Memorial Hospital. When public facilities began to be racially integrated in the 1960s, there was less need for a hospital serving only African-American patients. The racial integration of hospital medical staffs also meant that black doctors could treat patients in all of Charlotte's hospitals. In 1991, the former Good Samaritan Hospital building was demolished to make room for the NFL stadium. Although the hospital building is gone, Jane Wilkes is honored for her charitable works by the inclusion of her statue on the Mecklenburg Trail of History along the Little Sugar Creek Greenway.

Southern Manufacturers Club

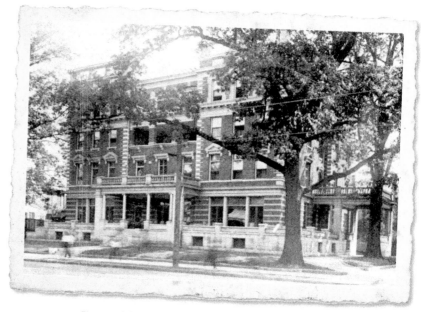

Photograph from *Story of Charlotte*, a 1913 installment in C.E. Weaver's Illustrated Cities series published by Central Publishing Co., Inc., of Richmond, Virginia

THE SOUTHERN MANUFACTURERS CLUB at 300 West Trade Street opened in 1894. At that time, larger cities of consequence – and those, like Charlotte, that aspired to be of consequence – established exclusive clubs where elite business leaders and professionals could gather and negotiate their business deals. Whether called "city clubs" or "university clubs," such prestigious invitation-only private clubs were founded in cities like New York and Washington, D.C. Following that trend, Charlotte's industrial titans established the all-male Southern Manufacturers Club. Over the next 20 years, Charlotte's manufacturing industry mushroomed into a very large scale sufficient to warrant the existence of such a club. This brick-and-marble building designed by famous architect Frank P. Milburn was located near the Southern Railway station (No. 44) on West Trade Street. It was immediately next door to the best-address-in-town home of Mrs. Stonewall Jackson, the widow of the famous Confederate general. The club, which catered to the financial elite, provided its members, many of whom were not Charlotte residents, with a home away from home. The club facilities included the usual amenities of a fine hotel, such as a ballroom, parlors, a dining room, and guest rooms. On May 21, 1918, the French "Blue Devil" soldiers, namesake of the Duke University Blue Devils, visited Charlotte. Although only a handful of the Blue Devils spoke English, they were feted by the titans of Charlotte business and industry at the Southern Manufacturers Club, of which James B. Duke is thought to have been a member when he lived in Charlotte. For several years, the Rotary Club of Charlotte held its weekly lunch meetings at the club. The Charlotte Kiwanis Club was organized there in 1919. The club building survived until 1936.

Lawing Building

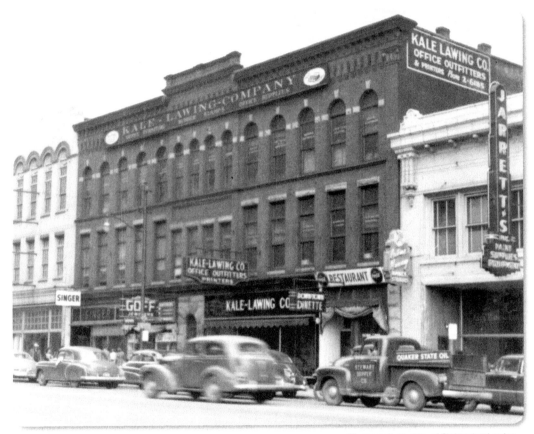

Photograph courtesy of Christopher Lawing

THE PIEDMONT CLOTHING COMPANY originally constructed this substantial building at 229 South Tryon Street as a factory. Factories like this in center-city Charlotte contributed to the evolution of Tryon Street from a residential street of fine houses into a commercial district. The Piedmont Clothing Company was active in 1899. Reflecting the change in technologies, by 1914 the building's primary street-level tenant featured Edison phonographs, which later came to be called record players. By the 1940s, the building was occupied by the Kale Lawing Company, which sold office furnishings and supplies to support Charlotte's growing office commerce.

Belmont Hotel

THE BELMONT HOTEL stood literally and figuratively in the shadow of the city's two leading hotels of the era, the Central Hotel (No. 5) and the Buford Hotel (No. 8). As a lower-priced hotel, the Belmont Hotel probably appealed to the cotton brokers, sellers, and other traders after a busy day of cotton marketing and shipping on College Street. Before Charlotte became the center of America's cotton textile manufacturing industry, the city was already a center of cotton trade. The cotton platform (No. 14), which paralleled College Street, was where cotton bales delivered by mule-drawn carts were loaded onto train cars for shipment to New England or "old" England primarily through the port at Charleston, South Carolina. Around the corner from the cotton platform on East Trade Street, the Belmont Hotel beckoned guests. Almost from the beginning, however, the hotel was downgraded to serve as an annex for one of the more prominent hotels. The 1899 advertisement for the Buford Hotel describes the Belmont Hotel as its annex. Later, the second and third floors of the Belmont Hotel became an overflow annex of the Central Hotel. The two hotels were connected by an enclosed overhead walkway (visible in the photograph) that extended across an alley behind the Central Hotel and was attached to the Belmont Hotel between the second and third floors, probably at a stairway landing. By then, the Belmont Hotel's first floor had been converted to commercial space where

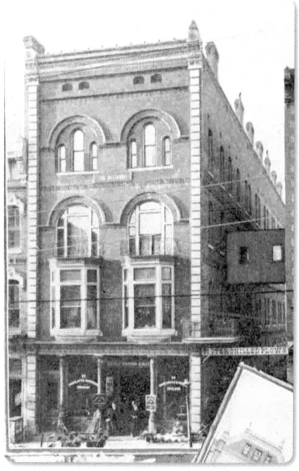

Photograph from Wade Harris's 1909 edition of *Sketches of Charlotte*

at various times furniture and clothing stores operated. Despite its economy-class standing among the hotels, the Belmont Hotel building survived until 1973 when it was the last of the three hotels to be razed.

Presbyterian College for Women

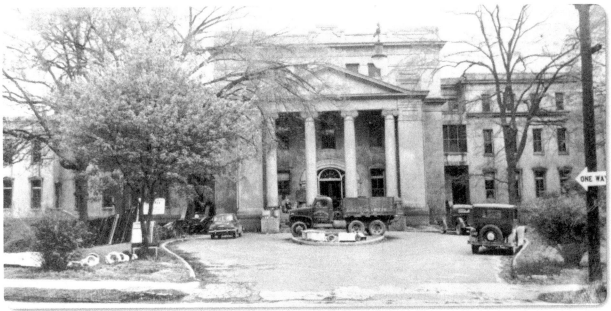

Photograph courtesy of Mary Boyer

THE PRESBYTERIAN COLLEGE FOR WOMEN located on North College Street was founded in 1857. At that time, it was known as Charlotte Female College. Then it was called the Seminary for Girls. Finally, after 1896, it was known as Presbyterian College for Women. The college occupied this monumental edifice on College Street, which was so named for this college. With its size, dome, and Greek columns, this building resembles the Chambers Building at the college's brother Presbyterian institution, Davidson College. In its time, the college's Main Hall was the most formidable building in the city not dedicated to manufacturing or commerce. In 1914, the educational institution housed in this building on College Street moved to Myers Park, leaving behind this building and its "Presbyterian" name. The 1914 version of the college in Myers Park relocated to the intersection of Selwyn Avenue, Queens Road, and Queens Road East. Adopting "Queens" from its new Queens Road location, it was renamed Queens College. The college, now more than 160 years old, is known today as Queens University of Charlotte. Later, this building became known as the College Apartments and housed 38 apartment units. It was razed in 1948 to provide a site for the city morgue, which also no longer operates at this location.

Latta Park

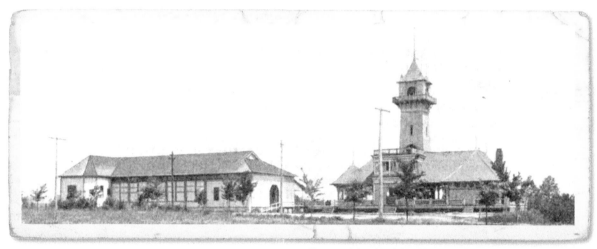

Photograph from Wade Harris's 1909 edition of *Sketches of Charlotte*

I N THE 1890s, Charlotte's first suburb, named Dilworth, was opened. Like many expanding communities across the United States, Dilworth was a "streetcar suburb" made possible by the construction of trolley tracks routed from the center city into open land that had formerly been a cotton field. As an amenity to attract residents to the cotton-field development, Latta Park and its buildings shown here were built to serve the suburban subdivision. As described in 1899, the park had two pavilions, a baseball park, a theater, a racetrack, camp meeting grounds, and a swimming pool with bath houses. The pool was described as "an immense basin with cement sides and bottom, its supply using pure spring water." Dan Morrill, Ph.D., leading Charlotte historian and history professor emeritus at UNC Charlotte, described the park as the "Carowinds of the 1890s, a place of bike races, balloon ascensions, and boat rides." In 1901, entertainer-sharpshooter Annie Oakley visited Charlotte and performed at Latta Park in the Buffalo Bill Wild West show. After Dilworth developed more fully, the park land soon became more valuable for housing lots than for park use. As a result, the elaborate pavilions and theater in the burgeoning suburb did not last long.

Park Elevator Company

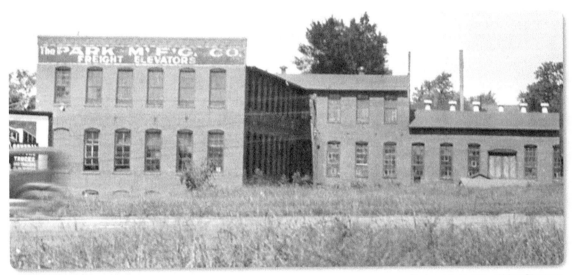

Photograph courtesy of Marc Silverman

THE PARK MANUFACTURING COMPANY opened in 1896. It soon was known as Park Elevator Company. The company evolved along with the technological advances in elevators. In the 1890s, Park elevators were hand powered. In 1905, the company began to build electric elevators that would typically be hoisted by steel cables. In the 1940s, the company added hydraulic elevators to its product line. Hydraulic elevators are pushed up by a solid steel piston rather than being lifted by a cable attached to the top of the elevator unit. The Park Elevator building, which had been converted into a tavern and night spot, burned in a spectacular fire in the 1990s.

Fourth Mecklenburg County Courthouse 1896

THE FOURTH Mecklenburg County Courthouse, which was located at 301 South Tryon Street, served the county from 1897 until the fifth courthouse, which still stands on East Trade Street, opened in 1922. When the fourth courthouse was built, Charlotte had not yet hit its growth spurt, which began around 1900, but the city was gaining fast on Wilmington in the contest to be North Carolina's largest city. Notwithstanding Charlotte's modest size, the city was immodestly boastful of its "finest courthouse in the state." The monumental structure, which was designed by famous architect Frank P. Milburn early in his career, reflected the aspirations of the community of approximately 18,000 to grow to become a city of prominence. The courthouse soon attracted Charlotte's first Law Building (No. 47). Soon after Camp Greene

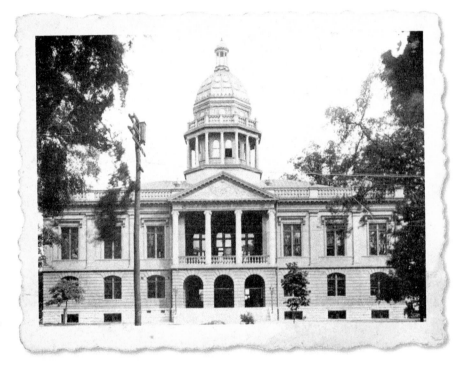

closed, Charlotte's Doughboy statue honoring the soldiers of Camp Greene was initially installed on the front grounds of this courthouse. The architect's announced "Grecian" style of the building, which somewhat resembles the U.S. Capitol, also symbolized that post-Civil War Charlotte had rejoined the Union in spirit as well as in law.

Elizabeth College

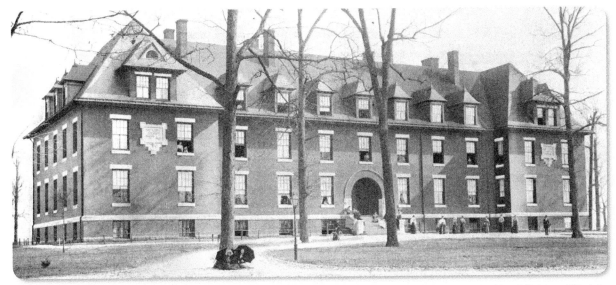

Photograph from Wade Harris's 1909 edition of *Sketches of Charlotte*

FOUNDED IN 1897, Elizabeth College for Women was in operation on its 20-acre campus in Charlotte for only a few years. In the early 1900s, the college relocated to Virginia along with its 30-member faculty and administration. The college's principal contribution to Charlotte was the "Elizabeth" name that it bequeathed to today's vibrant residential community known as the Elizabeth Neighborhood, which surrounds the former site of the college. This building on the Hawthorne Lane ridge at the east end of Elizabeth Avenue became the new home of Presbyterian Hospital, which moved from West Trade Street (No. 38). In the conversion to hospital use, the college's Music Conservatory building became a residence for nurses. In bygone eras, it was not uncommon for employers, whether schools, hospitals, or factories, to offer nearby housing, particularly to female employees. When Presbyterian Hospital built a massive new hospital on the site in 1940, it kept this building and incorporated it into its 1940 structure, which still stands. This building, however, was dismantled in the early 1980s as the present hospital expanded further.

Trinity Methodist Church

A CENTURY AGO, the Methodist denomination was known as the Methodist Episcopal Church. In those days, Charlotte had two prominent Methodist Episcopal churches on Tryon Street. This one on South Tryon Street was Trinity Methodist Episcopal ("M.E." in photo) Church at 401 South Tryon Street, which appears in 1899 photographs. It was formed as a break-off from its counterpart on North Tryon Street, the Tryon Street Methodist Episcopal Church South. Downplaying doctrinal differences as the cause of the split, the stated reason for the founding of Trinity Methodist Episcopal Church was that Tryon Street Methodist's "membership became so large as to require a division." Ironically, by 1930, these two congregations both abandoned their fine, tall-steepled buildings and reunited to form First United Methodist Church, which is still located on North Tryon Street.

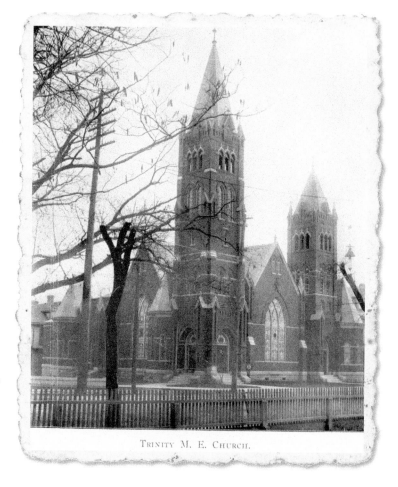

TRINITY M. E. CHURCH.

J. T. Williams Home

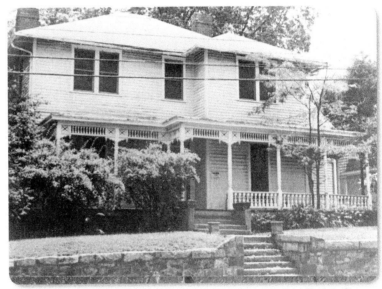

Photograph courtesy of the *Charlotte Observer*

THIS IS THE HOME of J. T. Williams (1859-1928). During his lifetime, J. T. Williams was widely regarded as Charlotte's most prominent African-American citizen. He was a physician, a businessman, and an educator. He left a mark on the community as one of the founders of the black-owned Mecklenburg Investment Company, which constructed the M.I.C. Building where black professionals had their offices in old Second Ward. He was president of The Afro-American Mutual Insurance Company that had its office on East Trade Street and was prominently advertised in the 1910 City Directory. He also founded one of North Carolina's first black-owned pharmacies, the Queen City Drugstore Company. The J. T. Williams home, which was quite fine in its day, stood as a monument to African-American success. A one-time diplomat, J. T. Williams served as American Consul to Sierra Leone in 1898. Although his house no longer stands, the J. T. Williams Junior High School bears his name, and his M.I.C. Building is still standing on South Brevard Street.

Clinton Chapel AME Zion Church

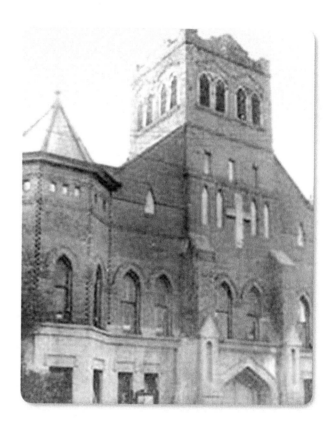

CLINTON CHAPEL AME ZION CHURCH on South Mint Street was one of many AME and AME Zion churches in Charlotte. A century ago, Methodist (now United Methodist) churches were known as Methodist Episcopal or "M.E." churches. Therefore, when Americans of African descent branched off from the mainly white Methodist Episcopal Church they founded the African Methodist Episcopal or "A.M.E." churches. AME Zion churches further branched off from AME churches to form a separate denomination that grew nationwide. Clinton AME Zion Church was the original church of the AME Zion denomination in Charlotte. It was founded in 1865 when enslaved African-Americans were freed at the end of the Civil War. It is very likely that this church was largely built by former slaves whose skills had been honed in specialized construction work during their enslavement. Many prominent buildings in the South, and even buildings as far north and as prominent as Georgetown University's early campus, were built using slave labor. The AME Zion denomination published a weekly newspaper, *The Star of Zion*, which served for many years as the de facto newspaper of the black community in Charlotte.

North Graded School

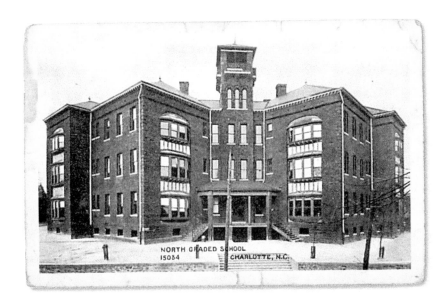

NORTH GRADED SCHOOL
15034 CHARLOTTE, N.C.

THE NAME OF the North Graded School at 401 East Ninth Street in First Ward references the innovative "graded" movement in education by which teaching evolved from the old one-room, all-grades-together school into the modern system of schools divided into grades. Opened in 1900, this was Charlotte's second "graded" school, the first being the South Graded School located in the former D. H. Hill building (No. 6). This school was designed by architect Frank P. Milburn whose work was found throughout Old Charlotte. Seen here is a recurring architectural motif in Charlotte, the double opposing stairways leading up to the front entrance of the building. The dual-stairs motif originated with the wooden Mecklenburg County Courthouse (No. 1)

around which the hamlet of Charlotte was founded in 1768. Another recurring architectural motif in Charlotte is the tower design shown here. This school predated the Southern Railway station formerly on West Trade Street (No. 44 and the cover of this book), which was also designed by Milburn. His design for the railway station included a tower feature strikingly similar to the tower on the school. Following another tradition in Charlotte – the reuse of sites for the same purposes for which they have previously served – this site is now occupied by another school, the First Ward Elementary School. The North Graded School building was brought down in the 1970s. The stone wall at the front of the school can still be seen in front of the current school.

D. A. Tompkins Tower

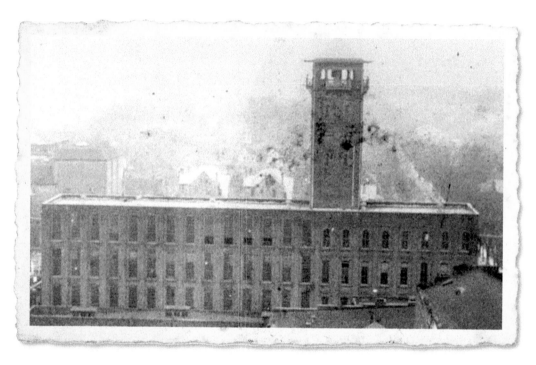

THE D. A. TOMPKINS BUILDING was important to Charlotte from several perspectives. At the turn of the last century in 1900, the city's skyline above street level consisted of church spires, a courthouse dome, a City Hall tower, two water-storage standpipes, and the D. A. Tompkins tower pictured here. Daniel Augustus Tompkins (1851-1914) never held public office, but he was Charlotte's leading citizen in the decades immediately before and after 1900. Raised in South Carolina but trained as an engineer at Rensselaer Polytechnic Institute in New York, Tompkins made his home and his fortune in Charlotte after he moved to the city in 1883. In addition to owning manufacturing facilities for textiles, his company boasted of having designed and built hundreds of manufacturing facilities in the Charlotte region. Although his textile plants were scattered throughout the region, his headquarters was located in this building on South Church Street in center-city Charlotte. Atop the sizable headquarters building, he constructed a tower that symbolized his manufacturing empire's dominance in the Charlotte region. Tompkins played a major role in the creation of the Textile School at North Carolina State University where he served on the board of trustees for two decades.

Circus Day and the Carson Building

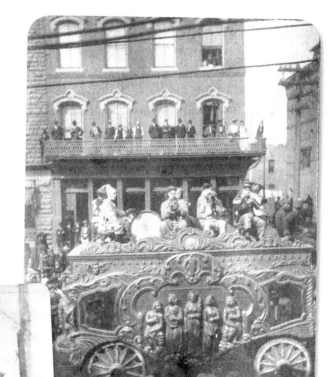

THIS 1901 PHOTOGRAPH shows one of the circus wagons carrying circus clowns as the wagon passes the Carson Building, which was the location of the North State Club at 200 South Tryon Street, at the intersection with Fourth Street. Crowds jammed the streets, windows, and balconies to watch the circus parade passing through the center of Charlotte. Members of the exclusive North State Club watched from their New Orleans-style wrought-iron balcony. A highlight of the parade was the march of the elephants two-by-two to the delight of the throng that overflowed into the streets barely leaving room for the parade's progress.

Photographs from Chunk Simmons family album courtesy of Noni Simmons

Catawba Power/ Southern Power Building

THIS SPECTACULAR BUILDING opened in 1902 at 212 South Tryon Street and housed the offices of the Catawba Power Company, now known as Duke Energy Company. There are no color photographs of the building, but it is frequently imagined by the artists of colorized photographs as a greystone building with brownstone accents at the level of its Parisian Mansard roof. Until it burned in 1922, this was the finest building in Charlotte. The building served two incongruous purposes – as an opera house called the Academy of Music and as an office building. In its latter role, it held the offices of James B. Duke, the tobacco baron and electric power magnate who brought abundant hydroelectric power to the Charlotte region. The company that Mr. Duke led was called Catawba Power Company, then Southern Public Utilities Company, and then Duke Power Company for many decades after his death in 1925. Charlotte's burgeoning growth after 1900 can be traced to the textile industry, which was made possible by the combined presence of abundant electricity and locally grown cotton. Mr. Duke created the philanthropic Duke Endowment

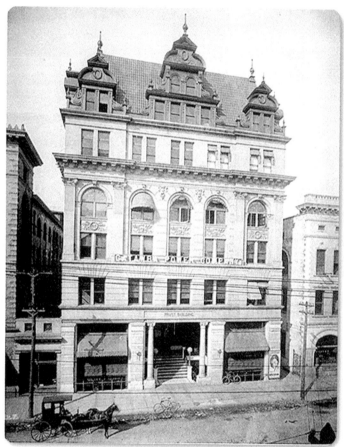

in Charlotte, and he funded the creation of Duke University from its predecessor, Trinity College, in his native town of Durham, North Carolina.

Stonewall Hotel

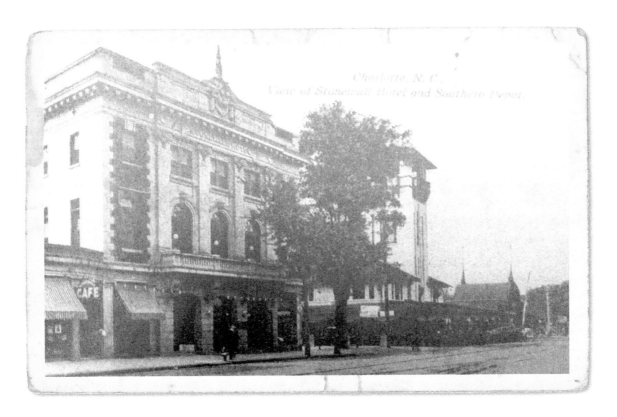

THE STONEWALL HOTEL at 535 West Trade Street was built in 1903. It stood next to the Southern Railway station (No. 44). Designed by famed architect Frank P. Milburn, the monumental urban style of the hotel with its white marble façade impressed visitors to Charlotte. Even before the Southern Railway station was torn down in 1962, the Stonewall Hotel declined as the number of train passengers declined. It was closed in 1958. The hotel was named for Gen. Stonewall Jackson because his widow's first home in Charlotte was located on the site the hotel occupied. When the venerated Mrs. Jackson moved from that site, she moved to the opposite side of West Trade Street into a new home closer to the Square.

Carnegie Library

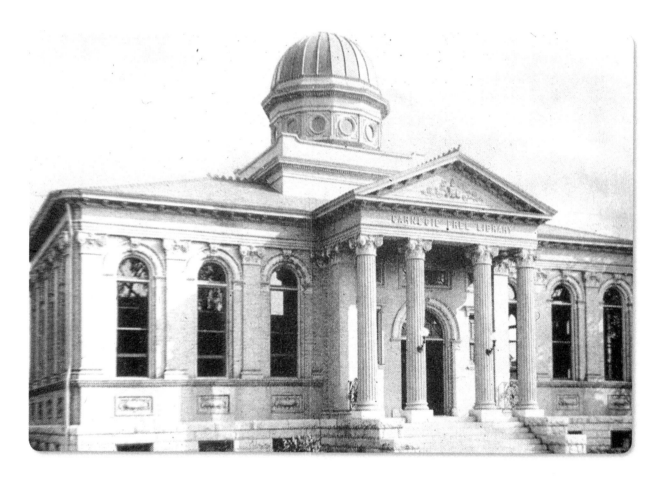

IN 1903, steel magnate and financier-philanthropist Andrew Carnegie from Pittsburgh donated $25,000 to build Charlotte's Carnegie Library at the corner of North Tryon Street and Sixth Street. As part of the bargain for giving the money, Carnegie required the city to provide a suitable site and ongoing operating expenses for the building. Since this library was built, the site has held a series of libraries. Charlotte was the fortunate beneficiary of Carnegie's unparalled generosity in donating libraries to cities and towns across America. Charlotte's Uptown Carnegie Library, however, was razed in 1954 and replaced in 1956 by a library structure designed in a 1950s style that stood until the 1980s (No. 99).

Charlotte Sanatorium

THE CHARLOTTE SANATORIUM also sometimes printed as "Sanitorium" was built in 1903 and designed by famed architect Frank P. Milburn. The building appears in photographs as late as 1974. This picture dates from 1940. Owned by a partnership of local doctors, the sanatorium, which was located within a block of the Professional Building where most doctors had their offices, advertised itself as a place for treatment of "fevers and pneumonias." In its earlier days, the facility marketed better as a sanitorium than as a hospital because many people in the earlier days viewed hospitals only as a place to go to die, in the same way that a hospice is viewed today. The later rise in acceptance of hospitals for treating illnesses led to the creation of Presbyterian Hospital, Mercy Hospital, and Charlotte Memorial Hospital. These larger,

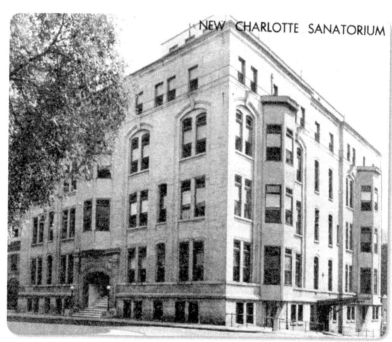

Photograph courtesy of the *Charlotte Observer*

more modern facilities replaced the Charlotte Sanatorium as the city's leading health-care facilities. Mecklenburg County also had a rurally located sanitorium to care for and isolate patients suffering from the highly communicable disease of tuberculosis before treatment by antibiotics became possible.

Presbyterian Hospital

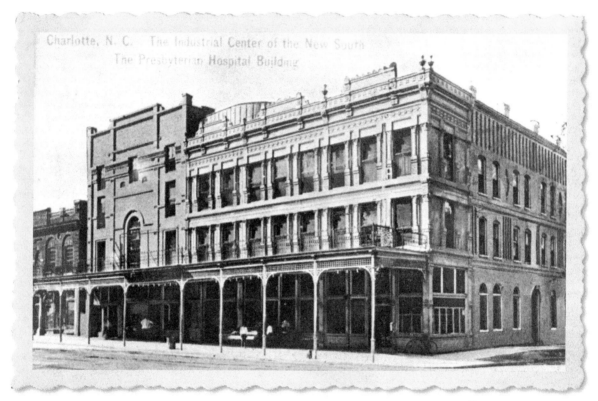

PRESBYTERIAN HOSPITAL operated at this site until 1918 when the hospital moved to its present location on Hawthorne Lane. In the old days, hospitals did not enjoy a good reputation. They were widely regarded as places where people only went to die. Beginning in 1903, the second site of Presbyterian Hospital, as shown here, was on the second floor of this building on West Trade Street, which had previously been the Arlington Hotel. As the name suggests, the hospital was founded and managed by members of Charlotte's Presbyterian churches. For a short time in the early 1900s, the N.C. Medical College was in operation nearby in the building that still stands at 229 North Church Street. This second Presbyterian Hospital doubled as a "teaching hospital" for the Medical College. In an effort to change the place-to-die reputation of hospitals, the hospital specified that only patients deemed likely to be cured or improved would be admitted to the facility.

Piedmont Fire Insurance Company

T HE BUILDING of the
Piedmont Fire Insurance
Co. in the second block of
South Tryon Street went up before
1899. Designed by noted architect
Frank P. Milburn, its developers
claimed to have given Charlotte its first
office building. In 1908 the building
housed Kings Business College, which
taught "bookkeeping, shorthand,
telegraphy & English." By the 1920s,
the Piedmont Fire Insurance Co. wrote
the largest amount of fire insurance of
any company in North Carolina. The
building came down in 1957.

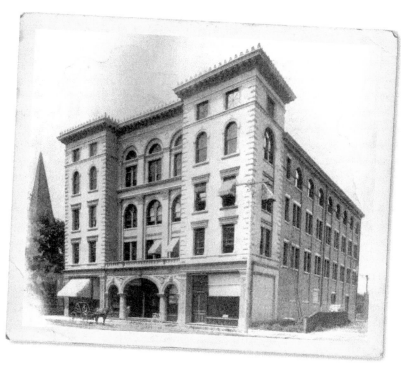

Photograph from Wade Harris's 1909 edition of *Sketches of Charlotte*

Latta Mansion

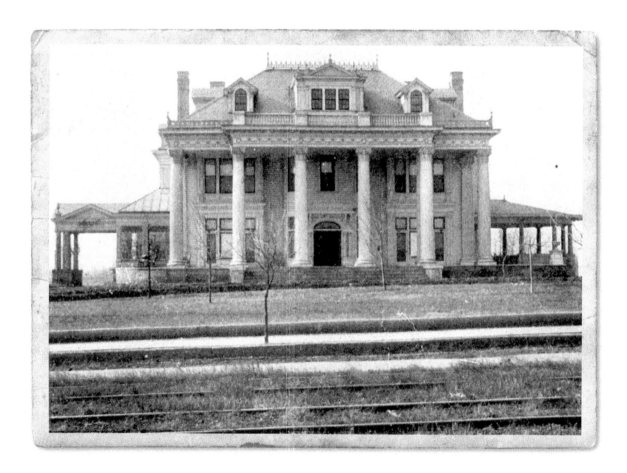

THIS IS THE LATTA MANSION, the showplace of the Dilworth neighborhood a century ago. Edward Dilworth Latta created Charlotte's first suburb, which he named Dilworth. He extended a privately owned street car line from Uptown Charlotte to the new Dilworth suburb south of the city. The main street of Dilworth was East Boulevard, which had a trolley line running down the center of the broad new avenue. Mr. Latta built this spectacular mansion for himself on East Boulevard where cotton fields had been cultivated just a few years before. The mansion was razed in 1966 to provide a site for Holy Trinity Greek Orthodox Church now at 600 East Boulevard.

Selwyn Hotel

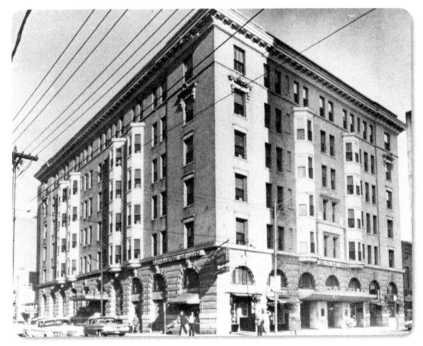

Photograph courtesy of the Charlotte Chamber

THE SELWYN HOTEL was considered a luxurious place to stay when it opened at 134 West Trade Street in 1907. The hotel had "150 elegant rooms" of which 75 had "private baths." The hotel's New York-styled ambience raised the standard for hotels in Charlotte. Its high-class cachet made it the appropriate venue for world-famous tobacco baron and electric power magnate James B. Duke and his brother Benjamin Duke to deliver a momentous announcement in 1911. At the Selwyn Hotel the Duke brothers, who were natives of Durham, N.C., announced that they were creating the Piedmont and Northern (P&N) electric railway, an interurban line that would serve Charlotte and Gastonia. In 1916, 48 prominent men met for lunch at the hotel and chartered the Rotary Club of Charlotte. The hotel featured bay windows of the San Francisco style. At one time, the hotel's restaurant offered fine French dining. By 1941, the restaurant at the hotel was the less fancy Gray's Dining Room. The once-stylish hotel closed in 1964.

Hawley Mansion

THE HAWLEY MANSION built in 1906 at 923 Elizabeth Avenue lasted until the 1980s. In 1930, it was known as Mrs. Morehead's boardinghouse. In another city growing less aggressively than Charlotte, this stately building near the courthouse might have become the office of a law firm as frequently occurs in other cities. However, Charlotte's explosive growth – more than tripling the city's population between 1970 and 2010 – created an inexorable demand for land on which to build new, taller buildings. It was this building's fate to fall to provide land for denser development.

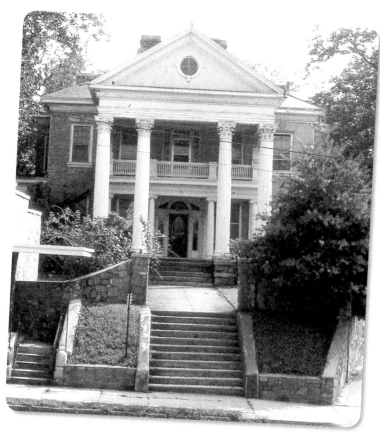

Photograph courtesy of Mary Boyer

Florence Crittenton Services/ Hotel Alexander

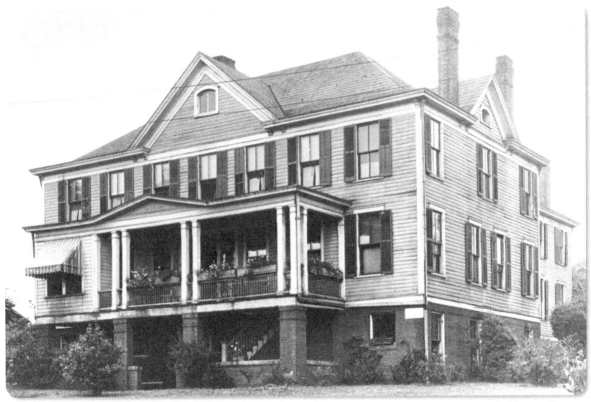

Photograph courtesy of the *Charlotte Observer*

IN 1906, the Florence Crittenton home opened at 523 North McDowell Street. The Florence Crittenton movement to provide supportive homes for unwed mothers began in New York. In 1903, Charlotte's first Florence Crittenton program was begun. This Florence Crittenton house was active until the 1940s when the home relocated elsewhere. The building was then converted into the Hotel Alexander, a hotel catering to African-Americans in a era of racial segregation throughout the South including Charlotte. In that era, the hotel's promotional postcards advertised that it was "one of the Nation's finest and most Exclusive and Newest Negro Hotels." Famed musician Louis Armstrong stayed there in 1962. The building was razed in 1973 when it was used by the fire department as a firefighting practice exercise.

Southern Railway Station

THE TRAIN CENTER of the South has always been Terminus, Georgia, which since 1845 has been known by its more famous, later name: Atlanta. In a time when train lines were new and rare, the first train tracks connected to Charlotte in 1852. That connection began Charlotte's important partnership with rail transportation. The Southern Railway Company's tracks covered the South, mostly branching out from Atlanta and from subcenters like Chattanooga and Spartanburg. This train station at 511 West Trade Street was the gateway to the city for visitors from across America, notably welcoming tens of thousands of Army recruits to Charlotte's Camp Greene Army base (No. 63) during World War I. By 1930, Charlotte received 100 trains per day. As a result, the Southern Railway station held the same great importance for Charlotte that is now held by the Charlotte Douglas International Airport. Because of its

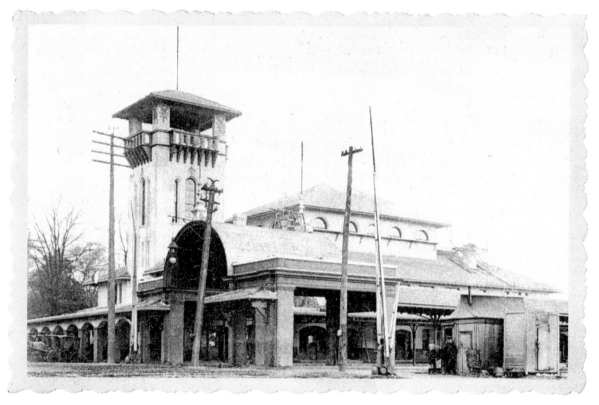

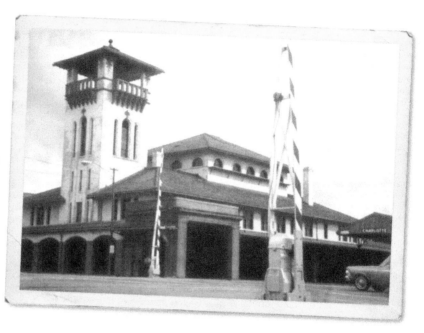

centralized geographic location and effective self-promotion, Charlotte benefited greatly from the routing of the main line of Southern Railway through Charlotte. Extending from New Orleans, through Atlanta, and through Charlotte on its northward route to New York City, the Southern Railway brought many of the nation's celebrities and dignitaries to Charlotte. When President Franklin Roosevelt's body was brought back to Washington, D.C., after his death in Warm Springs, Georgia, his train passed through Charlotte as did thousands of other trains over the decades. Clad in stucco, red brick, and exposed beams, the Spanish Revival station looked as if it had been modeled after a building in Santa Fe. This station, which rose in 1907, was designed by the South's most widely known architect of the era Frank P. Milburn (1868-1926). At that point in his career, Milburn was the official architect of Southern Railway. He designed several train stations for Southern Railway. The train station that still stands in Salisbury, North Carolina, which was also designed by Milburn, bears a striking resemblance to this station. By contrast, most of America's large train stations favored monumental marble or limestone construction. On this train station, Milburn replicated his earlier tower design already in

Charlotte at the North Graded School (No. 31). This landmark Charlotte train station was demolished in 1962 in connection with a citywide project to create "grade separation" of train tracks. To solve the city's traffic problems caused by trains constantly crossing city streets at street level or "at grade," the train tracks that had for years frequently blocked major center-city streets were elevated onto bridges passing over the streets. Trains still pass the former site of the Southern Railway station on West Trade Street, but they are elevated almost 20 feet above street level. The train station was rendered unusable by the grade separation. No longer serviceable, the building was razed. Its distinctive Spanish Revival tower has been replicated on the fire station on Wilkinson Boulevard and on various other structures in Charlotte. A color photograph of this important building appears on the cover of this book.

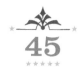
Independence Building

IN 1908, Charlotte saw the construction of the Independence Building, the first steel-framed "skyscraper" in North Carolina. The building had its public opening when President William Howard Taft visited Charlotte on May 20, 1909, to join the celebration of Mecklenburg Declaration of Independence Day. An engineering marvel, it signaled the arrival of steel-frame construction that was making possible tall buildings in places such as New York City and Chicago. It was designed by famed architect Frank P. Milburn who designed major buildings across the southeast, including several in Charlotte. This building was known over the years by various names, including the Realty Building. For most of its 73 years, however, it was known as the Independence Building. In 1918, it was the home of the Independence Trust Company, which gave it the "Independence" name. The Independence Building claimed in advertisements that it was the "first multi-story office building in North Carolina." Extremely prestigious at the time, it attracted business tycoons and professionals in both law and medicine. Originally built with 12 stories, the height of the building was increased in 1928 to 14 stories by adding two floors on top. The newer top two floors are easily identified in photographs of the building in its later years, such as the second photograph here. The Independence Building survived until 1981 when it was imploded while thousands of Charlotteans watched and photographed the building's crumbling eight-second demise.

Photos courtesy of the *Charlotte Observer*

YMCA

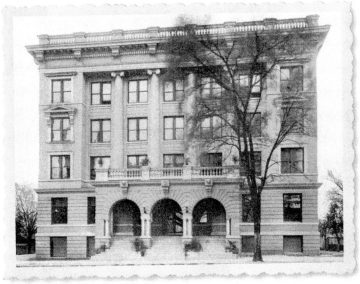

CHARLOTTEANS were very proud of this YMCA building, which went up in 1908 at 330 South Tryon Street. It was prominently located on South Tryon Street and was frequently photographed a century ago. This monumental building replaced the YMCA's castle-like, Victorian-style, brownstone structure opened by 1899 on South Tryon Street closer to Fourth Street. The YMCA of Charlotte began in 1874 when a group of young men founded it as a branch of the national Young Men's Christian Association (YMCA). Strong local financial support for the YMCA is evident from its progression through three buildings that housed the organization, each much larger than the previous one. The building was designed by architect C.C. Hook. This YMCA featured athletic facilities including an indoor basketball court and an indoor swimming pool. The pool was scandalously known as the place where men and boys customarily swam in the nude. Operating as a low-cost hotel for traveling men, the YMCA rented rooms to out-of-town visitors. The coming of Camp Greene Army base (No. 63) to Charlotte in 1917 presented the YMCA with its biggest opportunity and challenge. Tens of thousands of young men came as soldiers to Charlotte. A branch of the YMCA was opened on the base. With the support of the *Charlotte Observer*, the YMCA published the weekly base newspaper called *Trench*

and Camp. Soldiers often wrote home from Camp Greene on stationary imprinted with the American Flag and the YMCA logo. By 1924, the Charlotte YMCA had over 1,600 members. Because of its popularity as a hostel for young men to stay temporarily, this building was twice expanded until it held 107 rooms for resident members. This building, along with many other prominent structures in the city, was built by J.A. Jones Construction Co. Born in Charlotte, the J.A. Jones Construction Co. grew throughout the 20th century to become one of the world's largest and most prominent international construction firms. It ceased existence in 2004 after 113 years in business. This building survived until 1960.

Law Building (First)

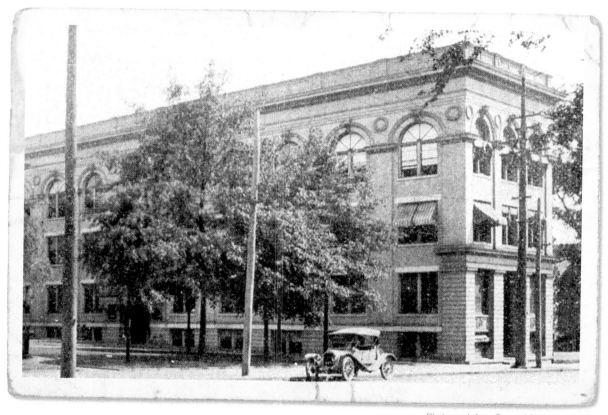

Photograph from *Story of Charlotte* (1913)

IN ITS HISTORY since 1900, Charlotte has been home to two so-called "Law Buildings" or "Lawyers Buildings." At both locations, the Law Buildings were built next to the Mecklenburg County Courthouse of that era. At each site, they were occupied by offices of lawyers. The first law building was a three-story edifice located next to the 1896 County courthouse on South Tryon Street (No. 26).

The three-story version of the building was in use by 1916. In later years, two floors were added to the top of the building making it a five-story building. By 1936, after the courthouse next door was razed, this building was no longer used for law offices. It was occupied by Sterchi's department store until Sterchi's built its own building farther down South Tryon Street.

Standard Ice & Fuel Company

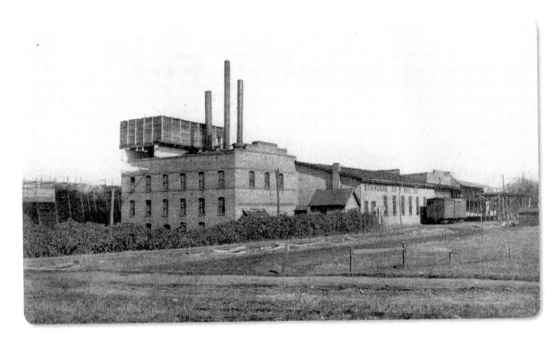

MAPS FROM THE EARLY 1900s place this ice-production plant near Twelfth Street north of Uptown Charlotte. The obvious superstructure on the top of the building served the refrigeration function, helping to dissipate heat the way the outdoor unit of a modern-day air conditioner blows out hot air as part of the process of chilling air to be ducted indoors. A century ago, this refrigeration factory served a vital purpose. In that era before electric refrigerators were common, families who could afford the service received daily home delivery of ice. They placed the block of ice in their "ice box," which served as a refrigerator. The ice melted, of course, and had to be replaced daily with a new block of ice. Ice delivery vehicles dispatched from this factory combed through the city. As its name discloses, the ice delivery service also offered the delivery of fuel for the home furnace, in other words, coal. Coal was needed in the winter to warm houses at a time of year when the cooling properties of ice were less needed. Reciprocally, in the summer, no one needed heating coal unless they were operating a steam-engine generator. During the warm months, the ice service was paramount. The combination coal-and-ice business was a practical marriage of services that allowed the enterprise to stay busy year-round.

American Trust Company

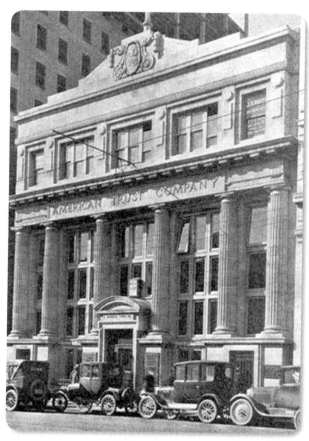

Photograph courtesy of the Charlotte Chamber

AMERICAN TRUST COMPANY occupied this august, five-story bank building at 206 South Tryon Street. The main room had an extremely high ceiling at the level of the tops of the columns. The bank stood in the shadow of the 12-story building next door, its long-time competitor Commercial National Bank (No. 52). Both banks survived the Great Depression when many other banks folded. In 1957, the two competing banks merged their businesses and their names to form American Commercial Bank. The success of their merger spawned visions of further mergers. In 1960, American Commercial Bank was renamed North Carolina National Bank, soon known as NCNB. The merger of the banks occasioned the construction of a large, new building, which was constructed in two assymetrical sections that together formed the new bank building at 200 South Tryon Street that still stands. First, NCNB razed this former American Trust building and built half of the new 1950s structure on American Trust's former footprint. When NCNB was able to occupy its new half-building on this building's footprint, the bank then leveled the tall, former Commercial National Bank building next door to clear space to build the other half of its new building. Today at 200 South Tryon Street, one can view the tall part of the current building on the left where American Trust Co. formerly stood and on the right, the shorter side-arm of the building where the narrow Commercial National Bank once stood.

Belk Store

THE BELK DEPARTMENT STORE chain was begun by William Henry Belk in Monroe, North Carolina. He soon expanded into Charlotte where his company occupied a group of buildings located on the 100 block of East Trade Street. This main building at 111 East Trade Street was labeled "Belk Bros. Dept. Store." Its left half appears in photographs taken in 1911. The store's front facade was doubled in width to this design by the late 1920s. The store was Charlotte's and, indeed, North Carolina's answer to Macy's, Bloomingdales, or Gimbel's department stores in New York City or Rich's in Atlanta. Until it was leveled around 1992 to make room for the 60-story Bank of America tower, this Trade Street store was the flagship of the massive retail chain of more than 300 stores across the South. The store's white marble façade made it one of Charlotte's landmark structures.

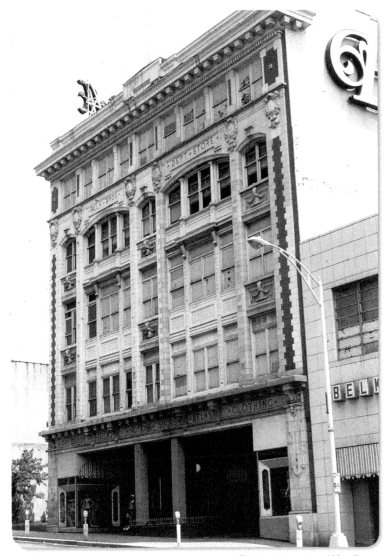

Photograph courtesy of Mary Boyer

Williams & Shelton

THE WILLIAMS & SHELTON CO. originated in Charlotte in 1893. It was already a successful business enterprise as "importers and jobbers of dry goods and notions" before it moved to this location at 406 South Tryon Street. By 1909, the company had opened a New York office at 667 Broadway. In 1912, the company led by Charlotte businessman Charles Williams built and occupied the pictured building. The store became the most prominent structure on the southernmost section of South Tryon Street, which theretofore had been occupied by the large homes of the city's wealthiest families. Charles Williams himself lived in a mansion further down South Tryon Street.

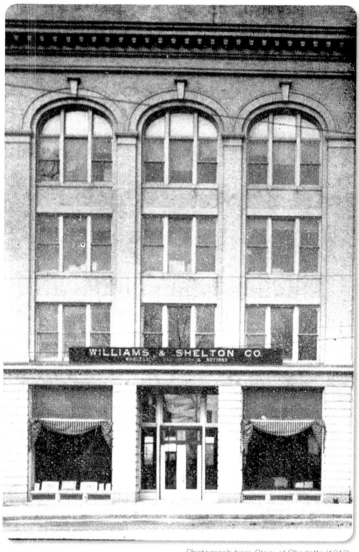

Photograph from *Story of Charlotte* (1913)

Commercial National Bank

THE TALL, SLENDER 12-story Commercial National Bank building at 200 South Tryon Street was Charlotte's second skyscraper. It was built soon after the first skyscraper, the 1908 Independence Building (No. 45). In this 1912 photograph of South Tryon Street, the Commercial National Bank, while under construction, already stood out among its neighbors. The bank was founded in 1874 and was located across the street until it occupied this prestigious building of marble and terra cotta in 1913. Commercial National Bank was the first national bank in North Carolina. In the early 1900s, the bank boasted of having the "largest capital and surplus of any bank in North Carolina." Its building held 170 offices and towered over its competitor American Trust Company (No. 49) next door. The two banks ultimately merged to become North Carolina National Bank, also known as NCNB. When they merged, the new NCNB building was constructed on the two-lot combined footprint of the two banks, both of which were razed, one at a time. (See No. 49.) This building survived until the late 1950s when it was the second to

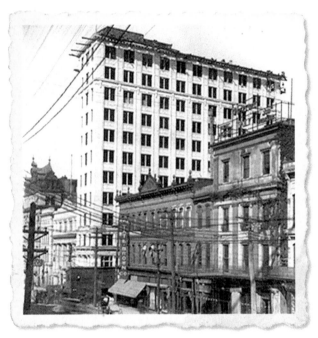

Photograph from *Story of Charlotte* (1913)

be demolished to clear the site for the northern section of the NCNB building, which was built in two separate vertical stages and which still stands at 200 South Tryon Street.

P&N Freight Warehouse and Loading Dock

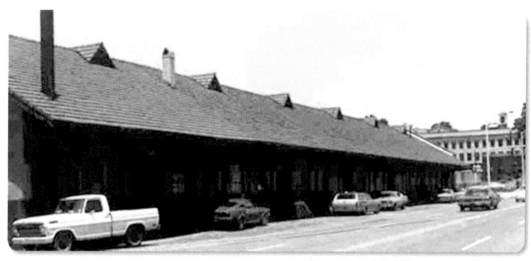

Photograph by S. David Carriker used with permission

IN THE EARLY 1900s, Charlotte was swimming in an abundance of harnessable electric current. James B. Duke had taken over the Southern Public Utilities Company, which was generating ever-increasing amounts of hydroelectric power. Most homes did not yet have electricity. Many textile plants generated their own electric power using on-site steam generators. Duke's challenge was to convince thousands of potential customers – especially large customers such as textile mills – to abandon their independent generating capacity and trust Duke's company to supply a reliable source of ample electricity at a reasonable price. In 1911, James B. Duke was the wealthiest North Carolina native, although he did not reside in North Carolina at that time. Mr. Duke visited Charlotte with his brother, Benjamin

Duke, to introduce their plan to build an electric train line called the Piedmont & Northern (P&N) train line. The Duke brothers' ambitious plan called for constructing rails and overhead electric wires to connect center-city Charlotte with center-city Gastonia and points beyond. They succeeded in forming the P&N system, which included the construction of a series of P&N stations at points along the line between Gastonia and Charlotte. The Charlotte terminus of the P&N system included a passenger platform and this warehouse building on South Mint Street behind the U.S. District Courthouse, which like the other P&N stations was designed by architect C.C. Hook. Many parts of the P&N rail beds are still active today, but the use of electric-powered trains on those rails was discontinued in 1954.

Clayton Hotel

THE CLAYTON HOTEL, which was built in 1913 at 132 West Fifth Street, occupied one of the more topographically unique sites in Uptown Charlotte. In a city where few streets rise noticeably in elevation from one intersection to another, the Clayton Hotel stood on the corner of Fifth Street and North Church Street where the street elevation is visibly sloped in both directions. As a result, the hotel had an entrance that faced each street. On the Church Street side, there was a Broadway-styled hotel entrance with an ornate platform awning supported by chains. The Fifth Street entrance also opened onto a sloping street. The architect selected an elevation for the first floor of the building and then adapted the entrances to fit the site. A pedestrian entering from Church Street walked up steps inside the portico to reach the first-floor level. The Fifth Street side of the hotel featured distinctive San Francisco-styled

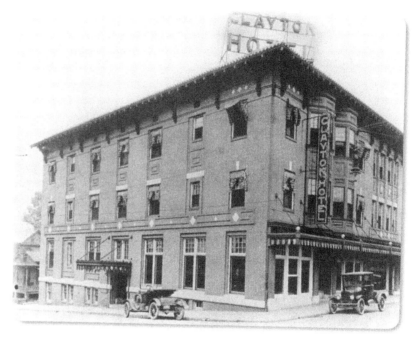

Photograph courtesy of Charlotte-Mecklenburg Historic Landmarks Commission

bay windows, which were particularly popular in the years following the San Francisco earthquake. This photograph was taken before Church Street and Fifth Street were changed into one-way streets. The cars in this photograph are both facing the wrong way under today's configuration of one-way streets. The building was razed in 1974.

Coca-Cola

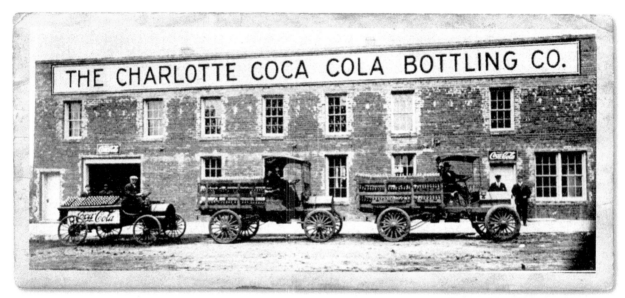

Photograph from *Story of Charlotte* (1913)

THIS COCA-COLA BOTTLING CO. building was active by 1913 producing Coca-Cola, which was invented in 1886. Before the Food and Drug Act introduced laws controlling narcotics, manufacturers of elixirs and tonics were legally able to include narcotic components that later required a doctor's prescription. Both before and after the law changed, innumerable bottled drinks were marketed and sold across America. Two early competitors in the non-narcotic "soft" drink business were Coca-Cola (originally concocted in Atlanta) and Pepsi Cola (originally created in New Bern, North Carolina, in 1893). From the earliest days, Charlotte had bottling centers to mix and sell the two colas under licensing contracts and franchises from the companies' headquarters.

Mecklenburg Hotel

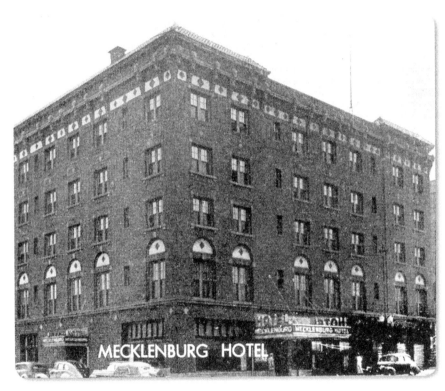

Photograph courtesy of the *Charlotte Observer* from "100,899: The Story of the Queen City of the Carolinas" published by the *Charlotte News* in 1940

THE MECKLENBURG HOTEL built in 1914 at 516 West Trade Street was designed by famed Charlotte architect Louis Asbury. Located directly across the street from the Southern Railway station and near the bus station, the hotel was kept in business for decades by railroad and bus passengers who found it a convenient place to spend the night on a layover. At one time, it featured a fine French restaurant, Chez Montet. In 1941, its plainer restaurant was simply known as the Mecklenburg Hotel Dining Room. The hotel advertised that it was "good enough for everybody, not too good for anybody" and "the Traveling Man's Home." It was the first of the city's hotels to advertise its air conditioning and automatic sprinkler system. Over the decades, especially after the train station was relocated, the hotel declined to the point that it closed in 1975. Then it burned in 1979 and was demolished. The hotel's burning was ironic because the hotel's postcards advertised that its "200 rooms of solid comfort" were "air-conditioned and fireproof."

David W. Erdman **71**

Masonic Temple

IN A TWO-DECADE SPAN of time beginning in the late 1960s, many significant buildings were destroyed in Charlotte. There were, however, three razings of landmark buildings that especially galvanized the passions of historic preservationists. One of those three lost buildings was the distinctive Masonic Temple at 329 South Tryon Street. This building's special contribution to the texture of Uptown Charlotte was its rare Egyptian Revival architectural style. Charlotte's Masonic Temple was designed by Charlotte architect Charles Christian "C.C." Hook (1870-1938) who was the city's first full-time, professional architect. The temple evoked the style and artistry of an ancient Egyptian temple. Masonic Temples in many cities were – and some still are – monumental structures rivaling federal courthouses with their imposing styles and sizes. In 1914, North Carolina's Masons began construction of Charlotte's Masonic Temple. Charlotte's temple was monumental and unique with its distinctive Egyptian Revival architecture. Following the style of numerous ancient Egyptian ancient temples such as the Luxor Temple, the Masonic Temple's facade was intentionally not built plumb-line vertical. Instead, the walls sloped inward to support the roof. The building featured other stylistic elements reminscent of the ancient Egyptian temples of the pharoahs. This building gave Charlotte a structure the style of which was unique in Charlotte and exceedingly rare in America. The razing of this irreplaceable landmark shocked the community. Even casual fans of Charlotte history mourned the loss of this

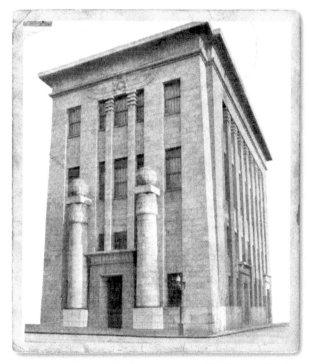

Photograph courtesy of the Charlotte Chamber

irreplaceable building. When now-defunct First Union National Bank destroyed the building in 1987 over the cries of preservationists, the Mecklenburg County Commission was finally moved to establish a revolving fund for historic preservation, which is administered by the Charlotte Mecklenburg Historic Landmarks Commission. The only other Egyptian Revival building known to exist in North Carolina is the 1927 Masonic Temple in Rocky Mount, North Carolina. That building is still standing and is likely to be preserved in perpetuity.

YWCA

IN 1914, the Young Womens Christian Association (YWCA) occupied this building on East Trade Street. Starting in 1909, Charlotte's YWCA established a program to fulfill an important need in the city: welcoming and helping young, single women who had newly moved to the growing city of Charlotte. This role was extremely important because droves of women left their rural farm homes in that era to move to Charlotte to work in the city's dozens of new textile mills. Helping young women adjust safely to the bustling city was a needed social service. The YWCA supported young women by offering them educational opportunities, including a night school for women only. The popularity of the YWCA's programs made necessary the association's growth into this building, which served until 1965 when the YWCA moved to Park Road. The 1914 YWCA, like the men's YMCA (No. 46), offered women a dining room, parlors, a gymnasium, and a small number of beds for residents until they resettled into suitable housing in the city. Housing at the YWCA was temporary, so the association maintained a directory of suitable boarding houses for women. Women had the opportunity to learn business-college skills for work in the fields of law, city government, banking, nursing, and sales. An employment bureau for women was later

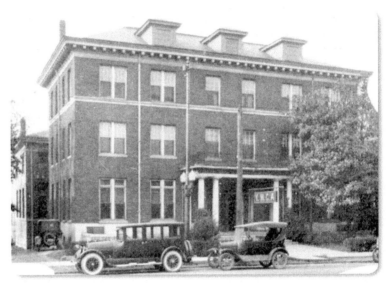

Photograph courtesy of the Charlotte Chamber

established. During World War I when Camp Greene brought tens of thousands of young male soldiers to Charlotte, the YWCA opened the YWCA Hostess House on the base. The Hostess House presaged the similar hospitality-away-from-home functions later formalized in World War II by the United Service Organizations (USO). In 1924, this YWCA was cited as "the only organization doing interracial work in Charlotte" because this all-white organization worked to promote the creation of a separate YWCA for African-Americans. In reality, some churches, and St. Peter's Episcopal Church in particular, were reaching across racial lines, but such public efforts were uncommon. The building survived until 1969.

Myers Park Gatehouse

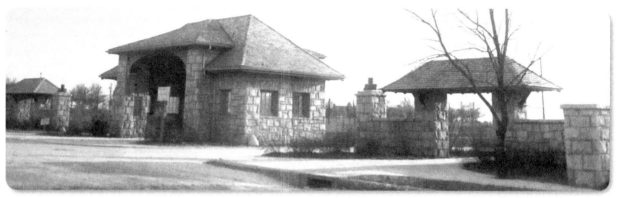

Photograph courtesy of J. Murrey Atkins Library, UNC Charlotte

CHARLOTTEANS HAVE ALWAYS thought of Myers Park as an exclusive neighborhood. Most, however, would not imagine that the original entrance to Myers Park included a massive gatehouse. The streetcars on Queens Road passed through the large gateway in the center building of the gate complex. The two pedestrian shelters still stand on East Fourth Street at Queens Road. An early suburb of a growing Charlotte, Myers Park was planned in the first two decades of the 1900s as a streetcar subdivision. It was built on either side of Queens Road, a sweeping streetcar loop bordered on each side by broad roadways for automobile traffic in both directions. The streetcars were taken out of service in 1938. The tracks were taken up later and the former track beds became parkway-style planting strips between the automobile lanes. Few Charlotteans can remember the streetcars that operated eight decades ago. As a result, pedestrians, bicycle riders, and drivers along the Queens Road loop do not readily recognize the connection between the grassy medians and their original purpose as streetcar beds. The streetcars ran on Queens Road and Queens Road East. Because Queens Road West was developed later, the streetcar tracks were never installed on Queens Road West before the whole system was discontinued.

Hexagonal House

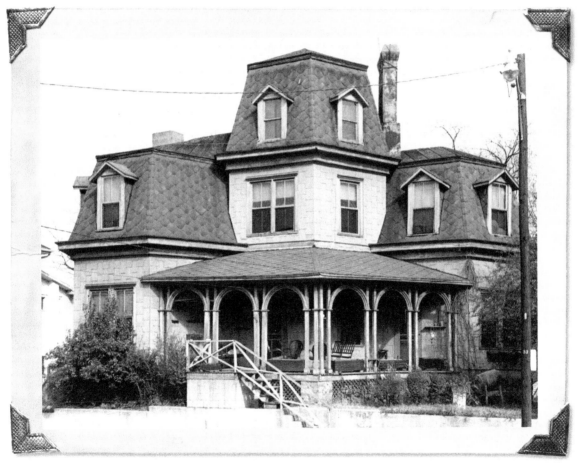

Photograph courtesy of the *Charlotte Observer*

IN 1869, soon after the Civil War, Charlotte's Harriet Morrison Irwin became America's first woman to patent an architectural design. She invented and patented a six-sided hexagonal house, which she believed was the most efficient design because no space was allocated to hallways. She also contended that her design encouraged better air flow in an era that was decades before air conditioning was invented. This is one of two hexagonal houses built in Charlotte using her concepts.

Ryder Flats

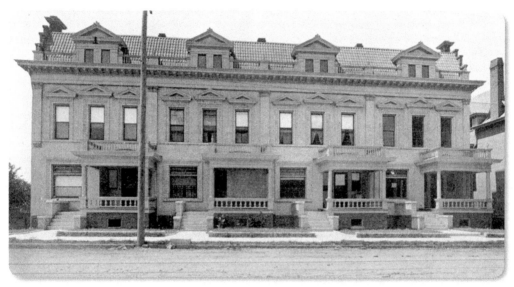

Photograph from Wade Harris's 1909 edition of *Sketches of Charlotte*

RYDER FLATS on East Morehead Street, with its prominent, protruding porches facing the street, was a one-of-a-kind residential building that offered Charlotteans a multifamily dwelling place architecturally reminiscent of the century-old rows of residences found on miles of streets in London, England. These Ryder Flats appear in 1930s photographs but do not appear in *Hill's Charlotte (Mecklenburg County, N.C.) City Directory* (1935). Although named "flats," which implies that each unit was a "flat" single story, these fine residences may actually have been individually occupied townhouses comprised of three stories and a basement. The apartments appear almost new in this 1909 photograph. Each of these four large units displays a basement window opening that likely doubled as a coal chute. A coal chute that allowed delivery of coal to the basement was a necessity for houses that were heated, as many were in that era, by coal-burning furnaces. At that time coal furnaces were replacing wood-burning stoves and fireplaces for home heating. In the 1920s, oil furnaces began to be installed in fine homes by companies like the E.P. Nisbet Oil Co. Soon, Charlotte supported many heating-oil companies as newer homes all came to be heated by oil. Only poorer areas, such as old Second Ward, continued to burn coal into the 1950s. The Blue Heaven moniker given to Second Ward came from the blue haze of coal smoke that floated over that neighborhood in cold weather.

Harry Golden House

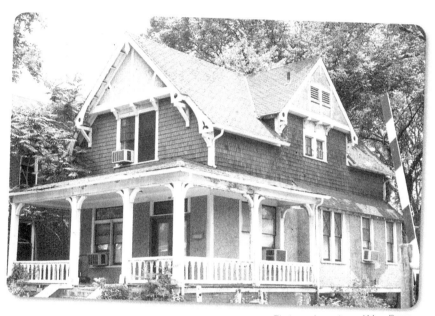

Photograph courtesy of Mary Boyer

T HE HARRY GOLDEN HOUSE was located at 1229 Elizabeth Avenue. Humorist-publisher Harry Golden (1902-1981) was Charlotte's most famous author and possibly Charlotte's most famous citizen in his time because of his outspoken and published advocacy for racial justice and labor unions. Golden was an immigrant to America who was born in the nation of Georgia. In 1941, he arrived in Charlotte where he spent the rest of his life. From Charlotte he championed civil rights throughout the time span during which the South progressed from Jim Crow laws to equal rights guaranteed by federal law. To his legions of readers across America, their first impression of the City of Charlotte was its distinction of being the home base of author Harry Golden. He won international renown in 1958 as the author of *Only in America* a compilation of humorous, social-commentary columns that he had written for his newspaper, the *Carolina Israelite*, which was published

in Charlotte every two months. In the South, and in North Carolina in particular, Jews were a tiny minority. Golden wrote not only for the local audience but also to present a Jewish perspective on life in America. He was friends with and admired by many famous people, including Eleanor Roosevelt, Martin Luther King, Jr., and Robert F. Kennedy. One of his closest and most frequent companions was iconic author and poet Carl Sandburg whose adopted home was in Flat Rock in western North Carolina.

Camp Greene Army Base

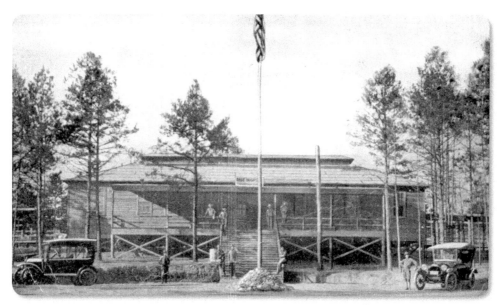

Photograph from 1918 postcard

CAMP GREENE was a large but short-lived Army base that was hurriedly constructed when America entered World War I. At the beginning of the war, Fort Bragg and other standing military centers did not yet exist. As a result, when the nation geared up for the fight in Europe, training centers for soldiers had to be created quickly so that America's fighting forces would be ready for combat. East Coast sites were favored because they were closer to the Atlantic ports from which ships would carry the troops across the Atlantic Ocean to Europe. Charlotte's city leaders lobbied forcefully for Charlotte to be selected as the site for a training base. Aside from extending an enthusiastic welcome to the Army, Charlotte offered the advantages of ample electric power, rail connections in every direction, and the availability of a hastily assembled 2,600-acre site with a plantation house. Charlotte won the lobbying contest for the base. It was given the name Camp Greene in honor of Revolutionary War general Nathanael Greene who won fame as the American commander in battles fought in the Charlotte region. None of the buildings constructed for Camp Greene remain. Only the command center that operated from the plantation house, which predated World War I and was known as the Dowd House, still remains. On this picture, as is the case with many photographs of Camp Greene buildings, the soldier figures and the flag are drawn in on the photograph.

Alexander Graham
Junior High School

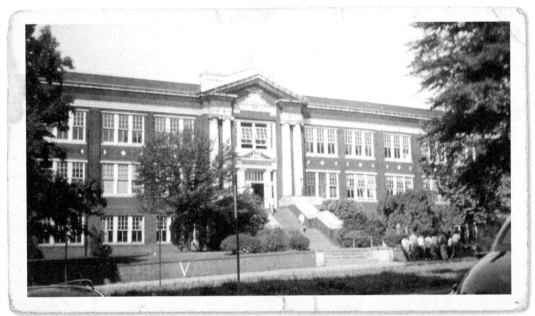

Photograph by James Millard Chesnut courtesy of Peggy Chesnut White

IN 1920 when this school was built, much of North Carolina was still in the era of rural union schools. Union schools housed all 11 or 12 grades at a single site. Across the state, such union schools were being newly built as late as 1922 and continued to operate into the 1950s. In contrast to the union school concept, in 1920, Charlotte's City School System established North Carolina's first junior high school, which was named Alexander Graham Junior High School. The name comes from Alexander Graham whom history remembers as the "father of graded schools in North Carolina." Graham was superintendent of the Charlotte schools for 25 years.

This school was commonly referred to by its initials as A.G. It was located at 428 East Morehead Street where the Dowd YMCA currently stands. In contrast to the modestly designed elementary schools that it replaced, A.G. made a strong statement on behalf of education. It stood as a monument to the junior high school concept on a prominent site near the center city. Perhaps in a nod to A.G.'s singular history, when the school's students were relocated in the 1950s to a new facility on Runnymede Lane, the new school retained the A.G. name. This 1920 school building appears to have served as a design model for Second Ward School built in 1923 (No. 72).

Dowd Flats

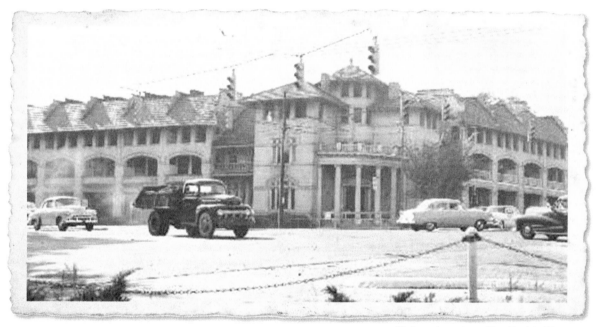

Photograph courtesy of the *Charlotte Observer*

THE DOWD APARTMENTS, sometimes listed as the Dowd Flats, stood on the corner of East Morehead Street and South Blvd at 1000 South Blvd from 1905 to 1954. The massive complex was a one-of-a-kind apartment building that mixed a Mediterranean architectural style with towers reminiscent of the Southern Railway tower (No. 44) facing each street.

Providence Road Apartments

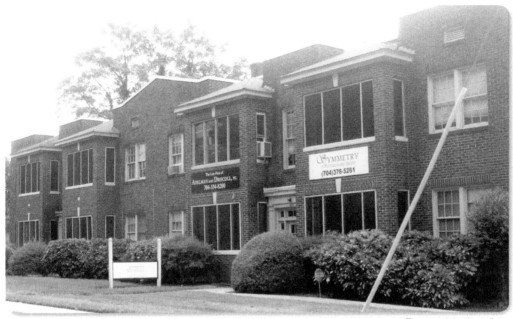

Photograph by the author

THIS EIGHT-UNIT APARTMENT BUILDING on Providence Road was probably built in the 1920s when similar buildings were constructed on the rise on the east side of Little Sugar Creek as Charlotte expanded and absorbed the Myers Park neighborhood. The architecture is characteristic of a style found throughout Old Charlotte. Charlotte has scores of distinctive fourplexes or "quadplexes" built in this architectural style reminiscent of the bungalow style of single-family residences. Charlotte also has a few apartment buildings still standing in Elizabeth and Myers Park that generally resemble this one, which was razed in 2007.

Chamber of Commerce

ONE CONSTANT in Charlotte's development and history has been the city's active spirit of boosterism, which has served the city well. Chief among Charlotte's boosters has been the Charlotte Chamber of Commerce, which was founded in 1915. Beginning in 1921, the chamber operated out of this building at 117 West Fourth Street. By 1924, the chamber's membership exceeded 1,200. This versatile building included a large meeting hall with a stage that was available for use by community organizations. Many civic groups, including women's clubs and Rotarians, met for luncheons or other meetings at the chamber building. On Sundays, the congregation of Holy Trinity Greek Orthodox Church held services there before the congregation built its own sanctuary. This building was long ago replaced by an early three-level concrete parking deck, which was subsequently

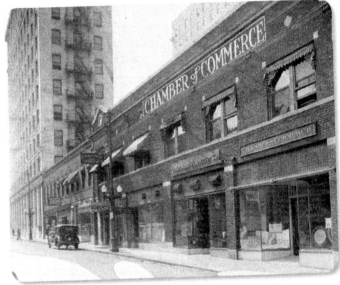

Photograph courtesy of the Charlotte Chamber

replaced by the present taller, more modern parking facility. The Charlotte Chamber, which now operates at 330 South Tryon Street, continues to serve as the leading voice promoting Charlotte's economic progress.

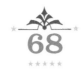

Professional Building

THE PROFESSIONAL BUILDING at 401 North Tryon Street housed 157 offices of physicians and dentists. Begun in 1921, it was located next to the EENT Hospital (No. 71). Two other hospitals, the Charlotte Sanatorium (No. 37) and St. Peter's Hospital, were located nearby in Fourth Ward. Two other hospitals, Presbyterian Hospital (No. 38) on West Trade Street and Good Samaritan Hospital (No. 19) in Third Ward, were a short walk away. Lavishly designed with white marble accents on a yellow Florida brick building, the building's formal appearance befitted its "professional" name and its prominent role in the city's medical history. Doctors from the Professional Building kept the restaurant across the street at the Barringer Hotel busy, especially at lunch. Like many of the city's major buildings, the Professional Building was designed by famed Charlotte architect Louis Asbury and built by J. A. Jones Construction Co. The building was brought down in 1995.

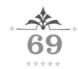

Wade Loft

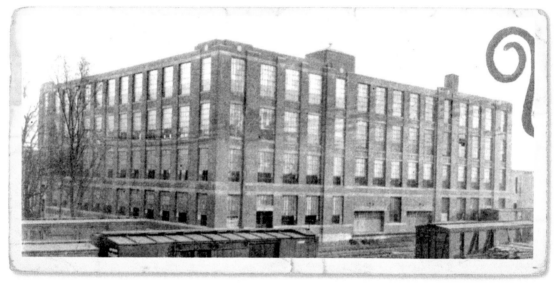

Photograph courtesy of the Charlotte Chamber

T HE WADE LOFT BUILDING was first announced in the *Manufacturers Record* published December 14, 1922. The report stated "H.M. Wade has plans by Lockwood, Greene & Co. for a loft building: 4 story; brick & timber; capacity 100,000 sq. ft. floor space; will accommodate 24 mfg. plants; equipped with 2 freight elevators; will have rear court for auto truck freight business; cost $200,000." Lockwood, Greene & Co. was a long-time Boston engineering firm with a branch office in Charlotte. The company was heavily involved in building textile mills and in the engineering design of several buildings in Charlotte in the 1920s. The Wade Loft building featured a U-shaped footprint. The outside bottom of the "U" faced the rail line. The courtyard interior allowed for truck access. The building burned in approximately 1979.

Merchandising District

CHARLOTTE'S MERCHANDISING DISTRICT served the sort of diverse marketing function reminiscent of the marketing areas in New York City, such as the garment district or the meatpacking district. It was designed for access by delivery trucks, which were dispatched to and from the district. It was also near the P&N interurban electric train terminus (No. 53) on Mint Street. During the early part of the 20th century, as horse-drawn vehicles were being phased out, business people could not yet know for certain where the future direction of transportation would go. Steam trains were well established; electric trains existed in some places including Charlotte; and trucks gradually gained market share for the distribution of goods. The Merchandising District was an active center for Charlotte's "break-down" role in commerce by which train loads of goods were broken down into truck-sized shipments and dispatched throughout the Carolinas. Businesses with names like Shaw Distribution Company, Independent Electric

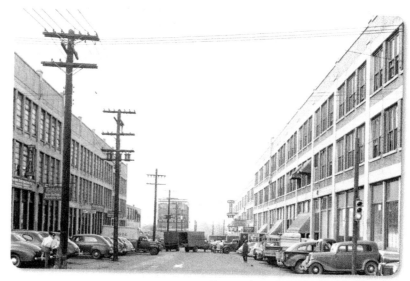

Photograph courtesy of the *Charlotte Observer*

Supply Company, and Mill Power Supply Company faced the wide alley between the two buildings that comprised the Merchandising District. Charlotte developed an identity during the first half of the 20th century as the center of distribution for the two Carolinas. By the 1940s, it was said that Charlotte was "the natural radial point for railway, bus, and air traffic." By the 1960s and 1970s, many distribution companies had moved out of the center city, choosing instead to locate near the interstate highways, in particular near Interstate 77 south of Charlotte in the Westinghouse Industrial District.

Eye, Ear, Nose & Throat Hospital

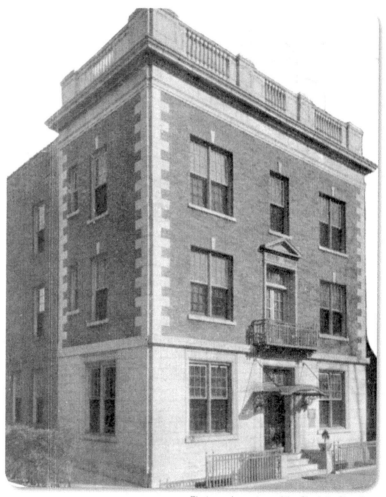

ALTHOUGH CHARLOTTE had a previous eye, ear, nose, and throat hospital on South Tryon Street, this Eye, Ear, Nose & Throat Hospital at 106 West Seventh Street, the corner of North Church Street and West Seventh Street, marked a dramatic step forward in the availability of specialized surgical care in Charlotte. It was constructed next to the Professional Building (No. 68) at the corner of West Seventh Street and North Tryon Street where most of the city's doctors had their offices. This hospital was created by four doctors for the eye, ear, nose, and throat medical specialties. The hospital held 24 patient beds. It was equipped with the most modern facilties, including x-ray. The building had a roof garden and a basement restaurant. Encased in white marble and yellow brick, this hospital introduced an urban, Northern style of architecture not commonly found in Charlotte. The hospital was torn down in the late 1970s.

Photograph courtesy of the Charlotte Chamber

Second Ward School

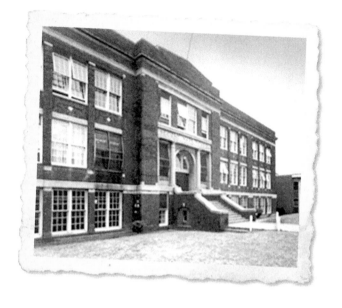

SECOND WARD SCHOOL was a high school located in Second Ward, which was also known as the Brooklyn neighborhood. The school at 501 South Alexander Street was a focal point of pride and unity in Charlotte's black community. The architecture of the high school greatly resembled A.G. Junior High School built a few blocks away just three years earlier (No. 64). Although Charlotte experienced limited racial integration of the previously segregated public schools as early as 1957, the schools were not fully integrated until 1971. Charlotte was ground zero for the legal fight over desegregation of America's public schools. In 1969, U.S. District Court Judge James McMillan ordered the Charlotte-Mecklenburg public schools to integrate racially by instituting cross-town busing of students to attain equal white-black racial percentages in all schools. Julius Chambers, Charlotte's famous civil rights attorney, won national fame for taking the case of *Swann vs. Charlotte-Mecklenburg Board of Education* all the way to the U.S. Supreme Court where he won a unanimous ruling that affirmed Judge McMillan's order. Meanwhile, urban renewal was in the process of razing nearly all of the buildings in Second Ward, eventually leveling Second Ward School itself. In theory, the residents of Second Ward (who were mostly African-American) had relocated, whether voluntarily or not, to west Charlotte. The new West Charlotte High School was intended to serve the relocated black community

with a fine school that was ostensibly "separate but equal." That plan was turned on its head when the court-ordered, cross-town busing sent white students from Charlotte's wealthiest neighborhoods to reverse-integrate West Charlotte High School. Many black churches could lay claim to being the center of various parts of the black community in Second Ward. However, only Second Ward School, which served the entire black community, stood alone as the unifying pillar of black pride and unity. The venerable school's final commencement was for its Class of 1969. The memory of Second Ward School burns brightly among its many surviving alumni who sustain the school's active alumni association.

Hotel Charlotte

T HE HOTEL CHARLOTTE opened in 1924 at 237 West Trade Street. It was a steel-framed building noticeably more modern than its competitors: the Buford Hotel, Selwyn Hotel, and Central Hotel. It was also larger by far than those hotels in height and number of rooms. It had 400 rooms "each with a private bath." The hotel boasted that it was the "largest hotel in the Carolinas' largest city." The hotel was designed by architect W. L. Stoddart and built by Charlotte-based J. A. Jones Construction Co. Hotel Charlotte proclaimed that it was the "hotel of first importance in the social, civic, and business life of Charlotte." It occupied a more favorable location than its main competitors, the Selwyn Hotel and Central Hotel, because it was closer to the Southern Railway station on West Trade Street. For a decade or so in the 1930s and 1940s, RCA Victor operated a recording studio in the hotel that catered to Southern musicians. The hotel hosted President Franklin D. Roosevelt's overnight stay in Charlotte. Perhaps the president's visit was the reason the hotel was later renamed the White House Inn in its declining years. Hotel Charlotte went out of business in 1973. The empty building survived

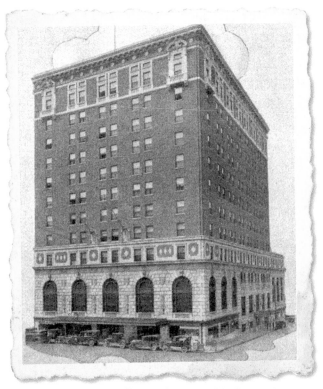

Photograph courtesy of the Charlotte Chamber

until 1988 when it was imploded on live national television as magician David Copperfield used the collapsing building as a backdrop for one of his magical illusions.

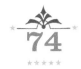
Race Track

(Left) photograph courtesy of Mary Boyer

(Right) photograph by James Millard Chesnut
courtesy of Peggy Chesnut White

THE FIRST CHARLOTTE SPEEDWAY was in operation for only three years, 1924 to 1927. During that time, however, the 1.25-mile, all-wood, oval-shaped race track was regarded as the finest race track in the southern United States. The second photograph taken on October 25, 1924, illustrates the intricate construction of the high-banked wooden racetrack. Osmond Barringer, a car dealer and Charlotte visionary, led the syndicate of investors who built the track. The first race was held in 1924. With a steeply banked wooden surface similar to that of a bowling alley and with its large grandstands, the speedway offered a "higher class" fan experience than dirt-track racing, which could be viewed at many county fairs. Its great popularity in Charlotte can be gauged by the large crowds and prominent patrons it drew. The newspaper published a photograph of Duke Power magnate James B. Duke seated in the front row at the first race. Though popular, the track was short-lived, largely due to its wood construction, which required constant, costly maintenance and replacement of wooden boards. Maintenance of a banked 1.25-mile wooden behemoth was much more difficult than, for example, maintaining the wood on a flat waterfront boardwalk. The race track enterprise proved unsustainable by 1927 as the fashion in automobile racing trended back toward shorter and cheaper dirt and red clay tracks at county fairgrounds across the state.

Walton Hotel

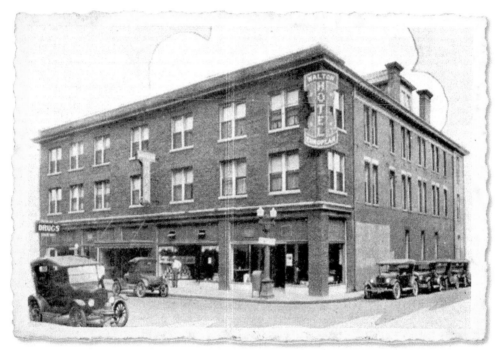

Photograph courtesy of the Charlotte Chamber

FIRST APPEARING in advertisements in the 1920s, the Walton Hotel was built at 204 North College Street during the automobile era. In contrast with earlier hotels that trumpeted such new concepts as private bathrooms, this more modern hotel boasted of telephones in the rooms and car parking nearby. Unlike Charlotte's hotels built in the horse-and-buggy age or the railroad era, the Walton Hotel was oriented to street traffic and the automobile. Standing in the shadow of towering warehouses that served the cotton platform (No. 14) and near the freight-focused train lines that ran parallel to College Street, this relatively low-cost hotel catered in its advertising to "plain folks." The Walton Hotel disappeared from photographs of the city around 1958.

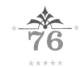

"Jesus Saves" Building

Photograph by the author

THIS BUILDING became known to many as the "Jesus Saves" building for an obvious reason. The cavernous structure at 200 Tuckaseegee Road was originally constructed in Uptown Charlotte as the Charlotte Civic Auditorium. The city's finances suffered during the Great Depression such that the city needed to sell the auditorium. The building was purchased by the congregation of Garr Pentacostal Church. From its location on North College Street, it was disassembled by the church and rebuilt to create this building in 1932. The church occupied the building at its Tuckaseegee Road location under the landmark "Jesus Saves" sign until 1989. At various times it was known as Garr Auditorium or Cannon Cathedral.

Lamp Lighter Restaurant

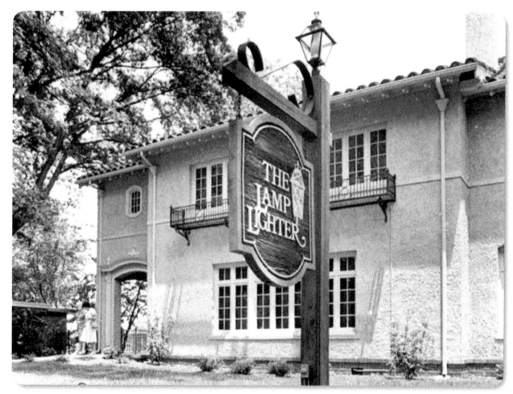

Photograph courtesy of the *Charlotte Observer*

THIS MEDITERRANEAN-STYLE house was built in 1925 by the Van Ness family. Located at 1065 East Morehead Street, the house was later converted into a fine-dining continental restaurant called the Lamp Lighter. The mansion-restaurant's romantic atmosphere, which featured fine paintings and intimate dim lighting, made it a favorite for Valentines dates and marriage proposals. Most Charlotteans of long standing hold fond memories of luxurious dinners at a relaxed pace in the elegant Lamp Lighter Restaurant.

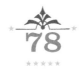
Wilder Building

Photograph courtesy of Ralston Pound

THE WILDER BUILDING opened in 1926 at the corner of North Tryon Street and East Third Street. It was named for the Wilder family that resided on the corner before the building was constructed. Mrs. Wilder, the widow of prominent physician Hillory Wilder, continued to live on this corner atop this building in a penthouse unit she designed for herself. It's never entirely clear what circumstances causes some buildings to lose all of their tenants, become empty shells, and then often be demolished. Such is the history of the once-distinguished Wilder Building. Charlotte's famous, powerful, 50,000-watt WBT AM radio station was founded in 1922 as North Carolina's first broadcast radio station. From 1924 to 1955 WBT radio sent out its broadcasts from the Wilder Building. Likewise, its television affiliate, WBTV, first signed on the air from the Wilder Building on July 15, 1949. The TV station continued to broadcast from there until 1955, which was the dawn of the color-TV age in North Carolina. One of the Wilder Building's tenants in the 1930s was Jacobson & Co. Tailors. An important later occupant of the building was City National Bank. The building was empty by the late 1970s, and it was leveled in 1983.

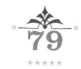
Law Building (Second)

THE LAW BUILDING on East Trade Street opened in 1926. The Mecklenburg County Courthouse was relocated in 1926 to a new state courthouse on East Trade Street. Shortly thereafter, a new lawyers' building or Law Building was opened next to the new Mecklenburg County Courthouse on East Trade Street. As happened with the previous law building (No. 47), the eight-story building soon proved to be too small. Two more floors were added on top of the building, which was eventually torn down around 1982. Many of Charlotte's largest and most prominent law firms had their first offices in this Law Building. This Charlotte historian opened his first solo law office in the front suite on the third floor.

Photograph courtesy of the Charlotte Chamber

Southern Railway Office

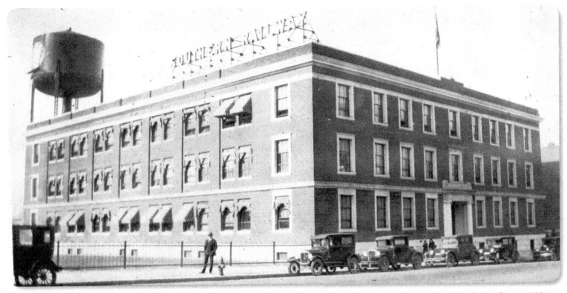

Photograph by James Millard Chesnut courtesy of Peggy Chesnut White

THE SOUTHERN RAILWAY office building at 713 West Trade Street stood across the tracks from the Southern Railway station (No. 44). Dating from 1926, this building was the headquarters of the railway's eastern region. The two buildings flanked the paired northbound and southbound tracks of the main line of the regionally dominant Southern Railway. The elevated tank in this photograph was used to supply locomotives with water to generate steam. A water tank was a required fixture at all train stations in the steam-engine era. The steam era ended when diesel locomotives replaced the steam-driven Iron Horses. The building was razed in 1992.

Observer-News Building

CHARLOTTE'S LAND USE has often been characterized by replacing buildings dedicated to a particular use with newer buildings that sustain that same use. For example, sites of old hotels often become the sites of new hotels. Likewise, banking corners have often remained banking corners in their newer-building versions. Such is the history of 600 South Tryon Street, the corner of South Tryon and Stonewall streets. In the economically supercharged era of the 1920s, many of Charlotte's pre-World War II buildings, including the Observer building, were constructed in the rapidly growing city. In 1926, the *Charlotte Observer* newspaper constructed this building and a publishing plant on the site, which had previously been a residential block. In the 1930s, with an eye toward expansion, the newspaper began the Observer Transportation Company. Possessing through its transportation company a system for fast distribution of the daily papers to surrounding towns, the *Observer* won the circulation battle over small-town newspapers throughout the region. By 1950, the *Observer's* circulation reached 135,000 per day. By then, the newspaper blanketed the region, having more subscribers outside of Charlotte than in the city. The

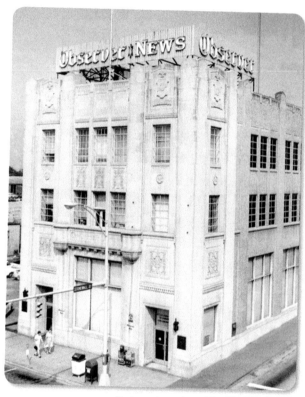

Photograph courtesy of the *Charlotte Observer*

use of this site for newspaper publishing was continued when this building was razed in 1970 to allow siting of the much larger Observer-News building that stood on this corner and covered the entire block until 2016.

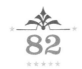
Pound & Moore Company

Photograph courtesy of Mary Boyer

THIS BUILDING was constructed at 304 South Tryon Street in 1929 by the owners of the site, the Tate family, for the Sears, Roebuck and Company as a department store to compete with the Ivey's and Efird's stores on Tryon Street. From 1950 to 1980 the building housed the Pound & Moore Office Supply Company that had moved its successful business from 213 South Tryon Street. Also in this building was Jack Wood, Ltd., the popular purveyor of fine men's suits for Uptown businessmen. Other businesses that occupied the building over the decades included Westbrook-Norton Insurance Agency, Piedmont Bank, Broadway & Seymour, and Jenkins Peer Architects.

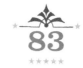
Power Building

THIS MONUMENTAL STRUCTURE known as the Power Building was the home office of Duke Power Company. Built in 1927, the building featured decorative elements reminiscent of those found on famous New York buildings from the same era, such as the Chrysler Building. Artistic features included carved insignia and copper-plated sections of the front façade. The building on the left is labeled "Southern Public Utilities Company." The Southern Public Utilities Company was renamed in honor and recognition of James B. Duke who massively expanded the company during his time running the organization. James B. Duke, a North Carolina native, had amassed extraordinary wealth in the tobacco industry before President Theodore Roosevelt took aim at monopolies and successfully forced Mr. Duke to sell off the majority of his tobacco holdings. The sale rendered him flush with cash, which allowed Mr. Duke to purchase tens of thousands of acres of Catawba River floodplain in the years following the 1916 record flood. Over the decades since then, the company that bears his name built and managed almost a dozen dams and created an equal number of lakes to generate hydroelectric power. Charlotte's huge Lake Norman is a man-made lake created by the Duke Power Company, predecessor to present day Duke Energy Company.

Photograph courtesy of Duke Energy Archives

Armory

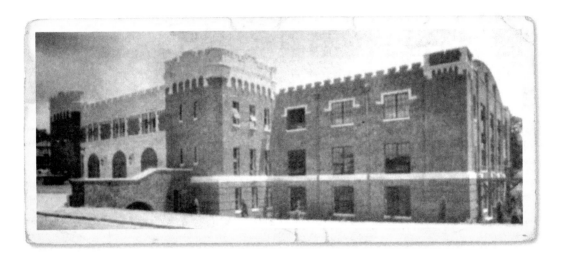

CHARLOTTE'S ARMORY AUDITORIUM was constructed in an amazing rush effort in 1929. It was built as a new city auditorium to host events for the 1929 reunion of Confederate soldiers, but it also served a dual purpose as the city's armory. The reunion itself was a massive event that brought tens of thousands of people to Charlotte to see the few remaining aged Confederate veterans. The Armory stood until it burned in 1954. The fire at the Armory was a memorable event in Charlotte's history. Today, fire-safety laws require signs to be posted outside of buildings to identify the flammable and other hazardous materials stored inside. In 1954, however, the firefighters at the Armory had no way to know whether live ammunition or other explosives were stored in the Armory at that time. As a result, residents living within several blocks of the Armory were evacuated from a large area until the fire could be safely extinguished. Although the Armory burned, no ammunition exploded, so its foundation survived. Soon thereafter the city built a recreation center directly on top of the Armory's old foundation. That recreation center, formerly called Park Center, is now known as Grady Cole Center. The transition between the 1929 red brick foundation of the old Armory and the 1950s-modern superstructure of the Grady Cole Center is plainly evident when viewing the building. In the 1960s, Park Center was the site of dances that attracted huge crowds of teenagers to hear music performers like the Atlanta Tams perform Carolina beach music to which the young people danced the unique six-beat-step dance known as "the shag" that originated at the beaches of the South Carolina coast.

S&W Cafeteria (later Southern National Bank building)

THIS WAS THE FLAGSHIP RESTAURANT of the S&W Cafeteria chain. It was built in 1932 at 116 West Trade Street. Charlotte has given birth to at least four notable restaurant chains: Bojangles', Showmars, Honey's, and S&W Cafeteria. S&W Cafeteria was started in Charlotte by Frank Sherrill and Fred Webber. Their company remained in operation until the last S&W Cafeteria closed in 1990. In 1954, there were S&W Cafeterias in nine cities stretching from Atlanta to Washington, D.C. That year S&W boasted "over 12 million meals served yearly." This marketing message may have influenced McDonald's when in 1955 its signs began advertising the millions (later "billions") of burgers it had sold. The interior design of the cafeteria on West Trade Street, even more than the exterior, featured dramatic art deco styling designed by noted Charlotte architect Martin Evans Boyer, Jr. In some cities such as Asheville, the exteriors of S&W Cafeterias featured fine marble and intricate art deco artistry reminiscent of Miami's South Beach. Charlotte's Uptown S&W Cafeteria is remembered by locals for its "hat locks" in which a man's hat did not merely hang on a hook but was clamped to the hat rack by a keyed clasp designed to keep men's hats from walking out with the wrong customer. This Uptown building was so opulent that it became a bank lobby for Southern National Bank after

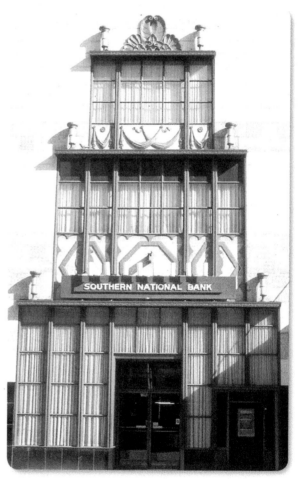

Photograph courtesy of Mary Boyer

this S&W Cafteria closed in 1970 and moved to the suburbs. This building was razed as part of the 1980s redevelopment of the site for the Marriott Hotel on West Trade Street.

Film Row

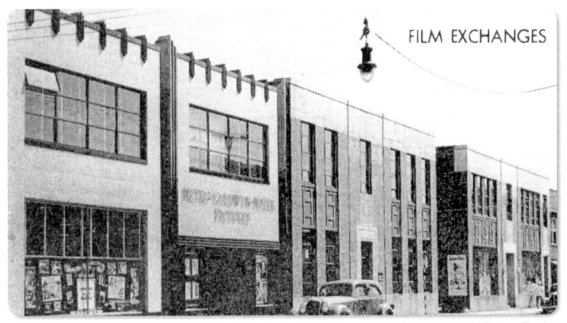

FILM EXCHANGES

Photograph courtesy of the Charlotte Chamber

CONSISTENT WITH THE CITY'S ROLE as the distribution hub of the Carolinas, Charlotte was a center of motion-picture film distribution during the golden age of movies. The major film-distribution companies, such as Metro-Goldwyn-Mayer pictured here, maintained their presence in Charlotte in a group of buildings known as Film Row on South College Street and on West Second, West Third, and West Fourth Streets. (The former West Second Street is now named West Martin Luther King, Jr. Boulevard.) In the 1930s, within that tight neighborhood of film distributors were located all of the famous movie distributors, including Columbia Pictures Corp., Fox Film Corp., Metro-Goldwyn-Mayer Pictures, Paramount Pictures, RKO, and United Artists Corporation. Nowadays, movies can be distributed electronically in digital format. In the golden era of movies, the wide-format movie film was transported to theaters in heavy, bulky containers for distribution across the Carolinas, Virginia, and parts of Tennessee. Thirteen film-producing companies distributed from Charlotte, shipping hundreds of movies daily to the movie theaters that were the entertainment mainstays of every town in the era before television.

Charlotte News

BEFORE IT MOVED into the Observer-News Building formerly located at 600 South Tryon Street, the *Charlotte News* newspaper was located in this building at 126 South Church Street. In 1909, the *Charlotte News* boasted "a circulation of more than 7,500 of the best people in the best part of the Carolinas." The *Charlotte News* was Charlotte's afternoon newspaper until it went out of business in 1983 as did most afternoon papers across the nation in that era. Evening news on TV supplanted afternoon papers sooner than it affected morning newspapers such as the *Charlotte Observer*.

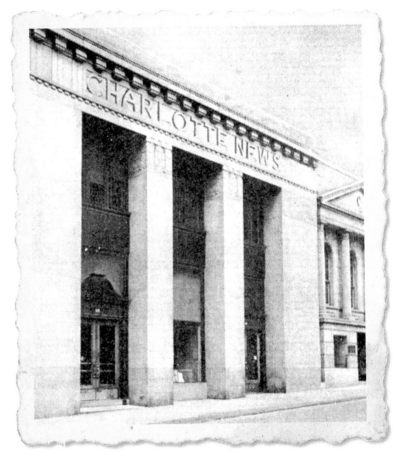

Photograph courtesy of the Charlotte Chamber

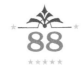

Charlotte Municipal Airport Terminal

THE NEW Charlotte Municipal Airport saw its first flight depart on May 17, 1937. The airport was city-owned and city-operated, hence its "municipal" name. This photograph shows the new terminal in 1938. A hangar was built nearby as a depression-era, jobs-creation project of the federal government's Works Progress Administration (WPA). The hangar, which is tiny by today's standards, still stands. This terminal building, however, was expanded and then later replaced in the late 1960s. The replacement terminal continued in operation until 1982 when the first section of the current terminal of the city's huge Charlotte Douglas International Airport opened. The Douglas name honors 1930s Mayor Ben Douglas who championed the creation of the city-owned airport.

Photograph courtesy of Rod Gatlin

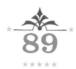
Virginia Paper Company

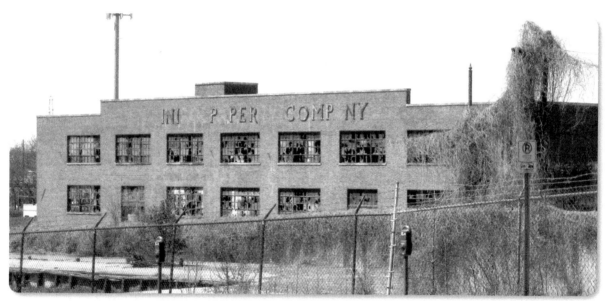

Photograph by the author

THE VIRGINIA PAPER COMPANY dates from 1914 in Virginia. This building at 416 West Third Street was constructed in 1937 to house the Carolina division of the company. By naming the Charlotte-based division the Carolina division, the company presaged two themes that would shape Charlotte's future. First, rather than referring only to North Carolina or South Carolina, as would have been typical in the era before good highways and big trucking companies, the Virginia-based company called its Charlotte's distribution warehouse the Carolina division. This recognition of the two Carolinas as a unified commercial zone has become more common in Charlotte's recent history as exemplified by the two-state hospital chain named Carolinas Medical Center. A further recognition of the unity between the two Carolinas occurred when the Charlotte-based National Football League team was named the Carolina Panthers in honor of both states. The flags of both states fly over the NFL stadium in Charlotte. The other theme underlying the naming of the Carolina division of the paper-printing company was its implicit affirmation of Charlotte's role as the leading distribution center for the two Carolinas and beyond.

Doctors Building

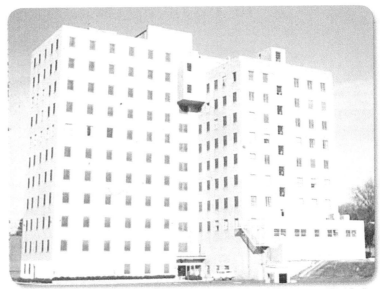

Photograph courtesy of Rod Gatlin

P HYSICIANS' OFFICES usually congregate around hospitals. In the early 1900s when Charlotte's medical community was focused in Fourth Ward near the hospitals, the largest concentration of doctors was located next door to the Eye, Ear, Nose & Throat Hospital in the Professional Building at 401 North Tryon Street (No. 68). The center of gravity for medical care moved to the wedge of land between Kenilworth Avenue and Kings Drive when Charlotte Memorial Hospital (now called Carolinas Medical Center) opened there in 1938. Suddenly the place for doctors to be was the new Doctors Building at 1012 Kings Drive.

Pitcher Street Shotgun Houses

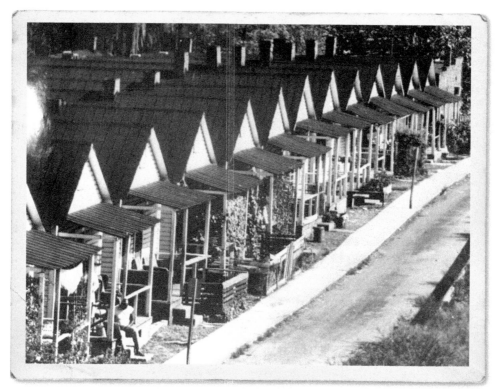

Photograph courtesy of the *Charlotte Observer*

PITCHER STREET was a two-block-long street near Third Ward, south of and close to West Morehead Street near the Cedar Street intersection. The street was obliterated by the construction of Interstate 277 south of the center city. In its heyday, however, it featured a remarkable row of identical shotgun houses, so named because all of the rooms in the house were aligned (it was said) such that if the front and back doors were open, one could fire a shotgun straight through the house front-to-back and not hit anything. Typically such houses burned coal, wood, or kerosene for heat and were rarely upfitted for oil heat, which was a later innovation.

E.I. Dupont Building

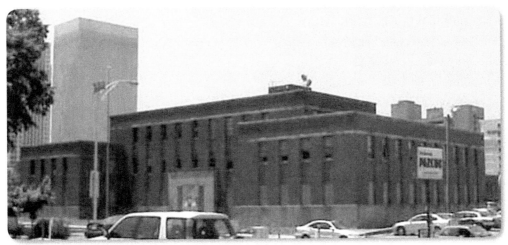

Photograph courtesy of Charlotte-Mecklenburg Historic Landmarks Commission

THE CHARLOTTE BRANCH of the E. I. Dupont Company operated out of this Uptown building at 427 West Fourth Street. Built before World War II, it was architecturally notable as an industrial building displaying art deco characteristics. The company probably benefited from being situated at the Charlotte terminus of the P&N train line (No. 53).

Federal Reserve Building

CHARLOTTE IS WELL ESTABLISHED as a major banking center. Large banks require the presence of the Federal Reserve system to furnish the banks with cash and, formerly, to clear millions of paper checks. North Carolina is located in the Federal Reserve district based in Richmond, Virginia. Since 1927, Charlotte has been the home of a busy branch of the Richmond Federal Reserve Bank. That branch was formerly located in this building at 401 South Tryon Street. In 1997, this building was razed by First Union National Bank, and the branch was moved to a new building on East Trade Street.

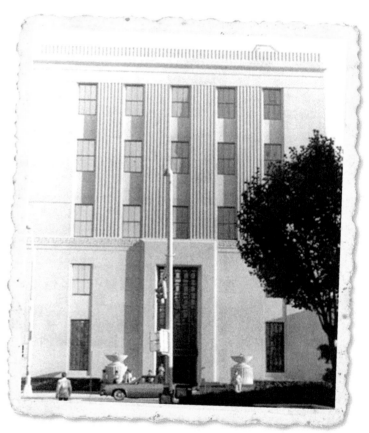

Photograph courtesy of the *Charlotte Observer*

94

Bus Station

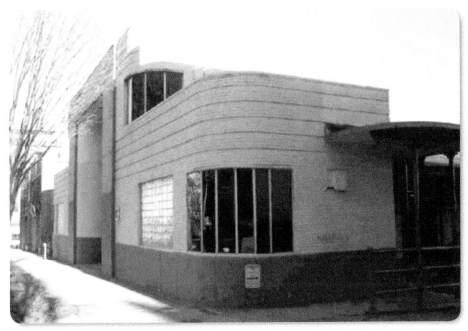

BUILT IN 1941, the Streamline Art Moderne style Trailways Union Bus Station at 418 West Trade Street was built so that competing bus lines could converge at the same modern location to board and to unload passengers. The Streamline style evolved out of Art Deco with its characteristic balanced lines and boat-like curved corners. This design by Charlotte architect James A. Malcolm was highlighted by glass brick accents often found in buildings of the streamline era. In its heyday, the station offered dining and showers to travelers. The bus terminal served the traveling public until it closed in 1987.

Crockett Baseball Park

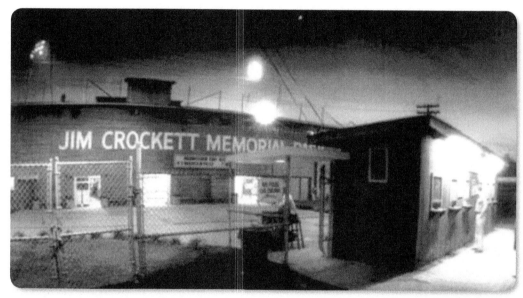

Photograph courtesy of the *Charlotte Observer*

CHARLOTTE'S PROFESSIONAL BASEBALL STADIUM at 400 Magnolia Avenue was originally named Clark Griffith Park. It was later known as Crockett Park. The 5,000-seat stadium, which was built entirely of wood, opened in 1941 when baseball was "America's pastime." By contrast, in 1941 the National Football League was new, and the National Basketball Association did not exist. The stadium was home to Charlotte's Triple-A professional baseball team until the stadium burned on March 16, 1985. Above the bleachers was a popular pine-paneled party room called the Crow's Nest. The Crow's Nest was

home each year to an opening-day singles mixer hosted by a single-women's social group quaintly named the Spinsters Club. This Charlotte historian met his future wife there in 1980. For 13 seasons beginning in 1976, the ball park was home to the Charlotte O's, so named because it was a Triple-A farm team of Major League Baseball's Baltimore Orioles. Charlotte fans at Crockett Park enjoyed watching the brief, very successful minor-league career of Charlotte O's player Cal Ripken, Jr. Ripken later became known as "The Iron Man" when he broke Lou Gehrig's record for consecutive MLB games played and became an MLB Hall of Famer for the Orioles.

Kress Store

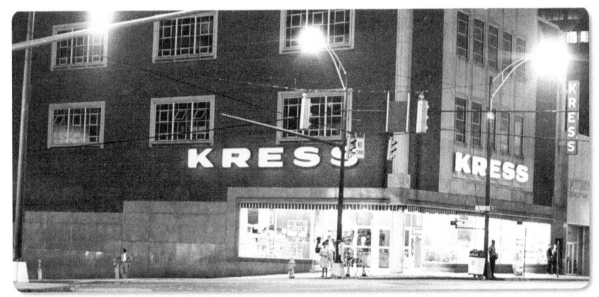

Photograph courtesy of the *Charlotte Observer*

FORMER S.H. KRESS FIVE AND DIME STORE BUILDINGS are some of the most celebrated architectural gems in cities across America, including Asheville and Greensboro, North Carolina, and Charleston, South Carolina. In many cities, those former Kress stores still stand as excellent examples of art deco design, lavishly decorated with white marble or colored tile facades. Remarkably, and rather singularly, Charlotte was not the beneficiary of such an architectural gem. The Kress store at 101 North Tryon Street in Charlotte occupied the landmark corner of Trade and Tryon streets at the Square. The former Central Hotel (No. 5) on that corner was demolished so that the Kress building could be constructed in 1942. Unlike its cousins whose decorative architecture adorned the main streets of hundreds of American cities, Charlotte's three-story Kress store was a plain, utilitarian, boxy structure devoid of special decor. Whereas Kress stores in numerous other cities have been protected and are prized for their ornate architecture, often featuring fine white marble, there was no outcry to save this Kress store when it was razed in 1973 to build the 40-story NCNB (now Bank of America) tower on the site.

Radio Center

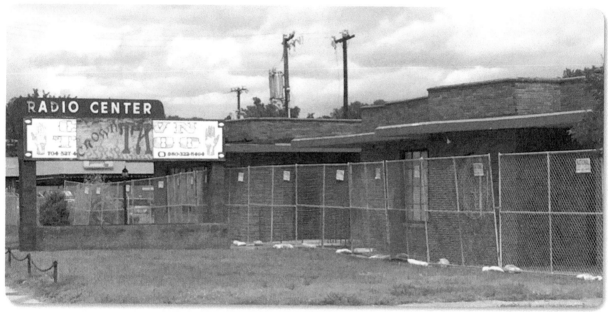

Photograph by the author

THE RADIO CENTER BUILDING located at 3229 South Boulevard was built in 1953 and was razed in 2016. Probably named for WAYS radio station, which began there, the Radio Center was an entertainment complex and mini-shopping center. When it was new and trendy, it was the site of teenage dances and fashion shows. To the end, it still had an abandoned ticket window. In its later years, the building housed low-rent apartments, small businesses, and a tattoo parlor. Located in the path of South End, Charlotte's fastest-expanding urban area, the dilapidated building no longer matched its trendy new surroundings. This picture was taken shortly before the building was leveled.

Independence Boulevard "elbow" intersection

ALTHOUGH NOT AS FAMOUS as the 90-degree "elbow" bends on New York's original Triborough Bridge or Chicago's former Lakeside Drive, Charlotte had a similarly remarkable elbow intersection on Independence Boulevard where the highway intersected with East Morehead Street and South Boulevard in a complicated three-level interchange. Charlotte's population exceeded 100,000 for the first time in the 1940 census, solidifying its position as North Carolina's largest city. When World War II ended, the city's leaders designed Charlotte's first cross-town expressway. It was six lanes wide at most points along its route, as wide as Atlanta's busiest streets. It circumnavigated center-city Charlotte, bypassing the city to the south and expediting the flow of traffic east to west across the city without passing through the city's core. Its most memorable feature, now long gone, was its elbow intersection. There, four lanes of traffic slowed to a crawl to execute a sharp 90-degree turn while

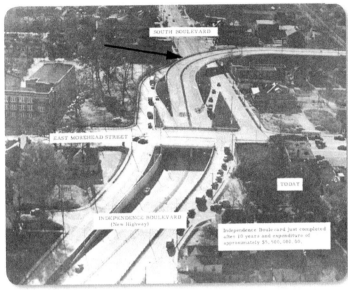

dodging traffic that merged seemingly from every side as motorists traversed the west-to-east highway around the city's core. When Interstate 85 opened to east-west traffic and provided a faster, safer bypass of Uptown Charlotte, the importance of Independence Boulevard diminished, which eventually led to its being dismantled piece by piece over the years.

Library

Photograph courtesy of Mary Boyer

CHARLOTTE'S 1956 LIBRARY was built on the former site of the Carnegie Library (No. 36). This structure lasted until 1989 when the current, much larger library building was constructed on the same site. In 1956, the library in this building became one of the first public facilities to eliminate racial segregation and open its reading rooms to all people.

Convention Center

Photograph courtesy of Mary Boyer

IN THE 1970s, Charlotte was ready to step forward as a growing city by creating a dramatically reinvented Uptown area. For the first time, buildings on several city blocks were connected by enclosed, elevated walkways dubbed the Overstreet Mall. At its zenith, the Overstreet Mall allowed people to walk all the way from Ivey's department store on North Tryon Street to the buildings of First Union National Bank on South Tryon and South College Streets without leaving an air-conditioned space. Approximately in the middle of the Overstreet Mall, the Charlotte Civic Center was connected by the elevated pedestrian system to the then-new Radisson Hotel. The Civic Center was the site of events such as the annual meeting of Charlotte's unique Good Fellows charitable organization. During the warm weather, there were weekly Alive After Five happy-hour events on the elevated outdoor terrace. The Civic Center was replaced by Charlotte's much larger Convention Center. This building was subsequently dynamited and the site cleared for new development.

EVERY LARGE CITY attains its size during that city's "golden age" when circumstances conspire to bring together people and purpose for that city's existence. Among America's large cities, Charlotte is a latecomer. It has joined the ranks of the big cities, however, by its uninterrupted growth while reinventing itself in every generation as it traversed its multiple "golden ages."

Continuous Growth is a major difference between Charlotte and the rest of America's largest cities.

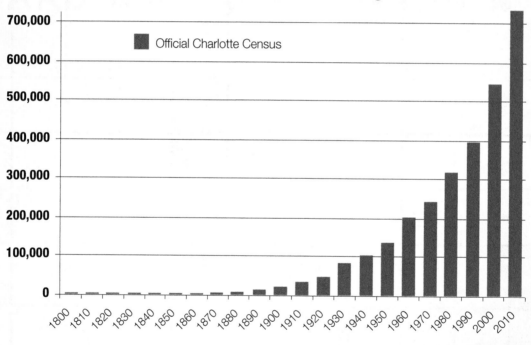

© 2017 David Erdman

Acknowledgments

MANY THANKS to all Charlotte photographers of the past 150 years who set up their cameras to take the pictures – and often developed and printed the photographs themselves – included in this book. Thanks also to the civic organizations that care for these records of Charlotte's past. The long list of individuals who helped make this book possible includes people who have lent me photographs to scan, shared old newspapers, and told me their personal recollections. I am grateful to all of them. Those individuals and organizations include the following:

Bill Barnhardt
Will Barnhardt
Taylor Batten
Mike Blair
Mary Boyer
S. David Carriker
Charlotte Chamber
Charlotte Mecklenburg Library
Charlotte Museum of History
Charlotte Observer
Jack Claiborne
Jerry Coughter
Steve Crump
Rennie Cuthbertson
Maria David
James Denk
Duke Energy Company
John Dwelle
Rufus Edmisten
Debbie Enna
Lynn Erdman

Bill Finger
Akeem Flavors
Bob Freeman
Rod Gatlin
Melisa Graham
Stewart Gray
Tom Hanchett
Steve Hockfield
Doris Hudson
J. Murrey Atkins Library at
 UNC Charlotte
Jane Johnson
Roy Kendrick
Frank Kiker
Mary Kratt
Christopher Lawing
Cindy Pauley Leone
Paula Lester
Levine Museum of the New South
Jaclyn Lyons
Beth Macdonald

Emily Erdman Mauney
Ralph & Sally McMillan
Natalie Erdman Moore
Bob Morgan
Dan Morrill
Allison Morris
Jackie O'Neill
Kay Peninger
Ralston Pound
Fabi Preslar
Anne Roberts
Chase Saunders
Marc Silverman
Noni Simmons
Chunk Simmons
Mary Todd
Richard Vinroot
Martin Waters
Jimmie White
Peggy White

Index

Alexander Graham Junior
High School..................... 79

American Trust Company 64

Armory 99

Belk Store 65

Belmont Hotel 36

Brevard Street Residence................. 21

Buford Hotel.............................. 22

Bus Station 109

Camp Greene Army Base................. 78

Carnegie Library 50

Carson Building........................ 47

Catawba Power/Southern
Power Building 48

Central Hotel............................. 19

Chamber of Commerce................. 82

Charlotte Municipal
Airport Terminal................. 103

Charlotte News........................ 102

Charlotte Sanatorium................ 51

City Hall (1888) 27

City Hall (1891) 31

Clayton Hotel........................... 69

Clinton Chapel AME
Zion Church....................... 44

Coca-Cola 70

Commercial National Bank 67

Convention Center.................. 115

Cotton platform...................... 28

Crockett Baseball Park 110

D. A. Tompkins Tower.............. 46

Doctors Building 105

Dowd Flats............................ 80

Ebenezer Baptist Church 24

E.I. Dupont Building 107

Elizabeth College 41

Eye, Ear & Throat Hospital 86

Family Dollar Store on
West Trade Street.............. 30

Federal Courthouse and
Post Office 32

Federal Reserve Building.............. 108

Film Row 101

Florence Crittenton
Services/Hotel Alexander 57

General Cornwallis's
Headquarters 16

Good Samaritan Hospital 33

Harry Golden House................. 77

Hawley Mansion 56

Hexagonal House 75

Hotel Charlotte 88

"Ice Cream Parlor House" 29

Independence Boulevard
elbow" intersection..................... 113

Independence Building................. 60

"Jacob's Ladder" School............. 26

"Jesus Saves" Building 91

J. T. Williams Home............. 43

Kress Store 111

Lamp Lighter Restaurant 92

Latta Mansion 54

Latta Park 38

Law Building (First) 62

Law Building (Second).............. 94

Lawing Building.................... 35

Library 114

Masonic Temple 72

Mecklenburg County Courthouse
1766, First................. 15
1836, Third 17
1896, Fourth................ 40

Mecklenburg Hotel................ 71

Merchandising District.............. 85

Myers Park Gatehouse 74

North Carolina Military Institute
(D.H. Hill School) 20

North Graded School.............. 45

Observer-News Building................. 96

Park Elevator Company..................... 39

Piedmont Fire Insurance
Company........................... 53

Pitcher Street Shotgun Houses..... 106

P&N Freight Warehouse
and Loading Dock 68

Pound & Moore Company.............. 97

Power Building..................... 98

Presbyterian College
for Women 37

Presbyterian Hospital................ 52

Professional Building................ 83

Providence Road Apartments.......... 81

Race Track........................ 89

Radio Center 112

Ryder Flats 76

Second Presbyterian Church........... 23

Second Ward School 87

Selwyn Hotel...................... 55

Southern Manufacturers Club 34

Southern Railway Office 95

Southern Railway Station............. 58

St. Mark's Lutheran Church............. 25

Standard Ice &
Fuel Company 63

Stonewall Hotel 49

S&W Cafeteria (later Southern
National Bank building)............. 100

Trinity Methodist Church................ 42

United States Mint 18

Virginia Paper Company 104

Wade Loft........................ 84

Walton Hotel..................... 90

Wilder Building 93

Williams & Shelton............. 66

YMCA............................. 61

YWCA............................. 73

Author's Biography

DAVID W. ERDMAN was born on the Fourth of July, 1949, on the Marine base at Camp Lejeune, North Carolina, where his father, a Navy surgeon, and his mother, a Red Cross worker, were stationed after World War II.

Reared in and around historic New Bern, North Carolina, Erdman learned at an early age the importance of historic preservation. He observed close hand the monumental restoration of Tryon Palace in the 1950s. At the same time, he was witness to the destruction of irreplaceable historic buildings, including New Bern's roundhouse, Kafer Hospital, Governor Tryon Hotel, and the Blades Mansion. He developed a passion for historic preservation, which is displayed throughout this book.

He attended Duke University as an Angier B. Duke Scholar. He was Duke's first graduate with a major in biomedical engineering. Passing up an acceptance to medical school, he earned a law degree at Georgetown University Law Center. While at Georgetown, he worked on the U.S. Senate Watergate Committee and lived on historic Capitol Hill.

While in law school, Erdman traveled extensively across the United States. Then he traveled to every corner of North Carolina during stints working at the North Carolina State Board of Higher Education, the North Carolina Department of Labor, the office of the North Carolina Superintendent of Public Instruction, and as advance man for Jim Hunt's first campaign for governor. During his travels, he sought out the historic sections of every city and crossroads.

In Charlotte since 1976, Erdman has become one of the city's best-known lawyers and historians. Since moving to the city, he has championed historic preservation as a private citizen, as an at-large member of the Charlotte City Council, and as a six-year member of the Charlotte-Mecklenburg Historic Landmarks Commission.

Erdman is married to Lynn Erdman. They have two grown daughters, Natalie Moore and Emily Manney.

He has authored many articles about history and historic preservation. His speeches about the history of Charlotte number in the hundreds. Erdman has collected thousands of digital images of Old Charlotte. This is his first book.

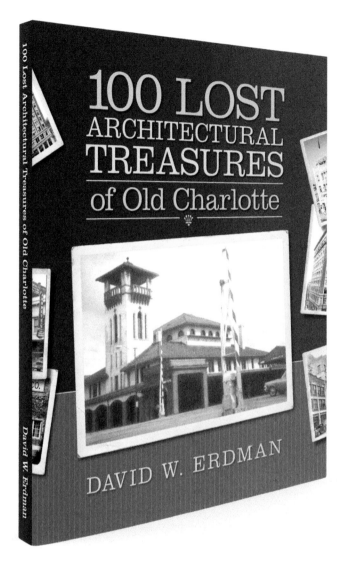

erdmanforcharlotte.com
erdman@charlotte-nc-law.com
Twitter: @DoubleLegal
704.333.7800

If you have Charlotte history to share, whether in family photo albums or old newspapers, I welcome a call or email from you, so we can collaborate to preserve this city's great heritage for future generations.

CPSIA information can be obtained
at www.ICGtesting.com
Printed in the USA
BVOW11*1945041117
499128BV00007B/15/P